ART
ANSWERS

Pastel
DRAWING

EXPERT ANSWERS
TO THE QUESTIONS
EVERY ARTIST ASKS

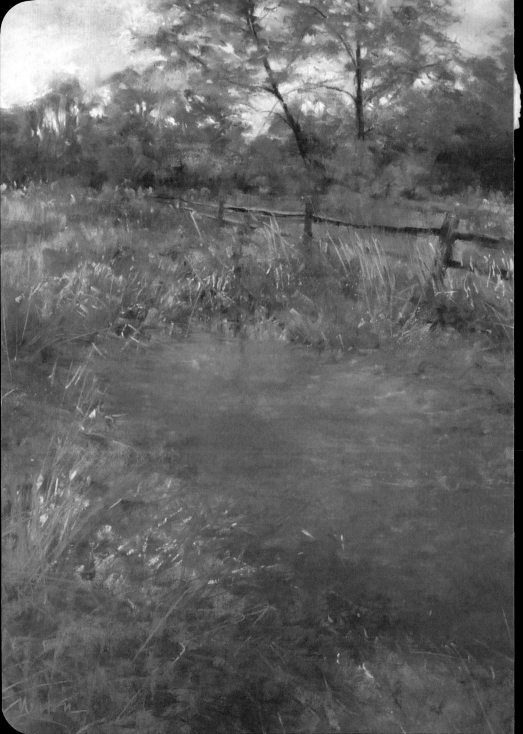

ART + ANSWERS

Pastel DRAWING

EXPERT ANSWERS
TO THE QUESTIONS
EVERY ARTIST ASKS

BARBARA BENEDETTI NEWTON

BARRON'S

All inquiries should be addressed to:
Barron's Educational Series, Inc.
250 Wireless Boulevard
Hauppauge, New York 11788
www.barronseduc.com

ISBN: 978-1-4380-0265-1
Library of Congress Control Number: 2013930222

This book is published and produced by
Quantum Books
6 Blundell Street
London N7 9BH

QUMAAPS

Publisher: Sarah Bloxham
Managing Editor: Samantha Warrington
Consultant Editor: Barbara Benedetti Newton
Editor: Sue Pressley
Assistant Editor: Jo Morley
Design: Stonecastle Graphics, www.stonecastle-graphics.com
Production Manager: Rohana Yusof

Printed in China by Midas Printing International Ltd.

9 8 7 6 5 4 3 2 1

Contents

Introduction

This book will introduce you to pastels—sticks of powdered pigments bound with gum or resin. Don't be misled by the name because pastels aren't just pale or light. They come in a wide range of colors from bright lights and muted neutrals to vibrant and dramatic bold or dark hues. The origin of the name is mid 17th century via French from Italian pastello, diminutive of pasta "paste."

My journey to pastel painting began with pen and black ink as I worked as a fashion illustrator. Many years later, I studied color through colored pencil. Like pastel, colored pencil is a dry medium and is not pre-mixed on a palette in the same way as paint. Because of this I learned about using colors by layering or juxtaposing hues directly on my working surface. The similarity between the two media ends there—colored pencil is precise and neat while pastel is known for its spontaneity and seemingly unplanned strokes of color.

When I first tried using pastel, it was in a workshop setting. At the time, it was important to me to learn a new medium step-by-step, starting with the basics. Learning strokes and techniques to obtain specific results would have made all the difference to me, but that was not the case, and I came away from the workshop discouraged. I set aside my interest in using pastels, though I continued to admire the pastel work of others. It was several years later when I began buying art instruction books about pastel that I became motivated to purchase a few sticks of color and give pastels another try.

I set out on my exploration of this fascinating medium by poring over the words and images of other artists, and it was through teaching myself that I learned the best way to teach others. I became an impassioned pastel instructor excited to help others. I welcome the opportunity to speak through this book to those interested in pastel to answer any questions you may have. This book can help you embark on a journey that will change your artistic life. If you currently work in a medium that uses a brush to interpret large passages of color and form, you will find that what you know will transfer easily to this medium and add to your experience with pastel.

The process of applying pastel is immediate and fast with no waiting for it to dry. A painting can be created "alla prima" in one sitting, working "plein air" (outdoors from life) or in a studio setting. In a studio setting, you can walk away from a painting session without having to wash brushes or clean a palette. Upon your return, colors will not have dried to a different hue; everything will be as you left it and you can continue.

This book contains examples and text about various established techniques.

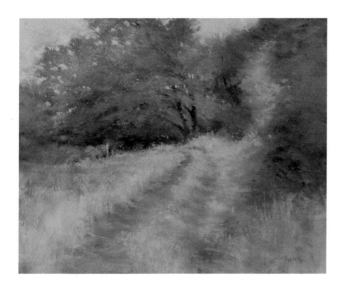

Left: Glory Days by Barbara Benedetti Newton *Pastel on paper.*

Practicing these until you get a result similar to the example is a good starting point. As you develop your unique style as an artist, your technique will simply be your own process of rendering with this medium to obtain the result you desire. I have found that it is after an artist becomes skilled at composition and technique, that their unique voice can be heard most easily. The ability to communicate your personal vision and the story you want to tell to those who view your paintings is of primary importance. In my opinion, it is more important than technique, style, or subject.

For me, painting with pastel is a dance between the artist, the paper, and a stick of color. The interchange is exhilarating as well as challenging and sometimes even exhausting. A drag and lift of the pastel stick creates a sheaf of dried grass; the edge of the pastel touches the paper abruptly for the bent branch and twig. The nuances and subtleties that are possible with pastel are unlike any other medium I have used. The play of texture against texture is exciting and color combinations as one color is dragged over another are captivating.

My words of advice are to have fun and, most importantly, to paint every day. Becoming a pastel master is like learning any other skill—it will take practice, trial and error, and the capacity to not take yourself and your work too seriously during the learning process. Have fun!

Barbara Benedetti Newton

1

PASTELS AND THEIR HISTORY

What are pastels?

Pastels are made from finely ground pigments bound together with a small quantity of gum to form a stiff paste, which is then shaped into round or square sticks and allowed to harden.

The word "pastel," in fact, is derived from the Italian word *pastello*, which means paste.

Chalk pastels, both hard and soft, are the most widely used of the various pastel types and are the type on which this book places most emphasis.

Below: *There are chalk pastels (in stick and pencil form), oil pastels, and water-soluble pastels.*

What is the history of pastel?

Pastel was "invented" by Jean Perreal, an artist who joined the magnificent retinue of Louis XII in the summer of 1499, hoping to gain fame by recording the French conquest of Northern Italy. He is now remembered only for the revolutionary medium he employed to enhance his sketches, which consisted of pure pigment bound with gum. Its advantages were immediately realized by Leonardo da Vinci (1452–1519), who called it the "dry coloring," method while his contemporaries named it *pastello*, from pasta (paste). He confined its use, however, to highlighting his charcoal and red-chalk drawings.

The 18th century

But it was the independent and sophisticated women of the Venetian Republic who were responsible for the first great surge of popularity in the medium's history, and its true potential was developed by one of these, Rosalba Carriera (1675–1757).

The still life was a speciality of another pastellist, the Swiss Jean Etienne Liotard (1702–1789). Concerned above all with realism, he deliberately tilted the plane of the table in one study, to give us a better view of the fruit and other objects on it, foreshadowing Cézanne's ideas about truth to the unchanging realities of form.

From Delacroix to The Impressionists

The world of the pastel portraitists crashed on July 14, 1789 with the outbreak of the Revolution. Their art was associated too much with the frivolity of the *ancien régime*, and pastels were little used until Neo-Classicism in turn, fell before the Romantic offensive. The role of the great Eugène Delacroix (1798–1863) in opening the eyes of a generation which craved emotional stimulation after the loss of empire and glory was crucial. Eugène Boudin (1824–1898) used Delacroix as his model in the hundreds of rapid pastel sketches which he executed on the Norman seacoast. Edouard Manet (1832–1883) liked to use the pastel stump to blur the outline of his images, giving them the spontaneity of out-of-focus photographs. His first important pastel, of his rather bored wife reclining on a soft blue sofa, is a perfect example of this technique.

Degas was a superb draughtsman, more interested in composition and the depiction of movement than in the play of light on landscape. While his fellow Impressionists concentrated on working outdoors directly from nature with oil paint—although Claude Monet (1840–1926) sometimes used pastel—Degas withdrew to his studio and began his daring experiments on foreshortening or

cropping the figures in his compositions and simulating the artificial light of the stage, to give us our first truly modern images. His secret as a pastellist was to build up pigment in successive layers, avoiding the dulling effect of fixative on pastel by making up his own secret formula. This fixed each layer securely without any loss to the brilliance of the tones—the lustrous red hair and creamy skin of his nudes, or the sheen on the coats of his prancing racehorses.

Pastel in our age

At the end of the 19th century Odilon Redon (1840–1916) brought pastels to the service of Symbolism. Whereas the Impressionists had used the medium to

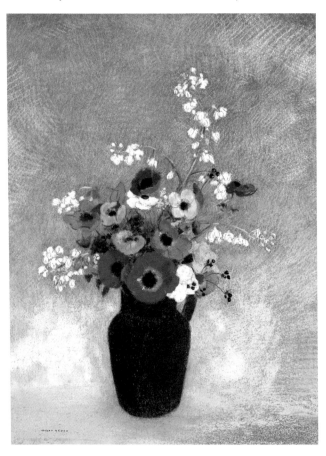

Left: Large Green Vase with Mixed Flowers by Odilon Redon, 1840–1916, Museum of Fine Arts, Boston
Odilon Redon frequently used the techniques that he had perfected in working with charcoal, putting in fields of color to set off his exquisite flower studies. He would either blend them thoroughly or use them crushed to produce the very soft-edged areas, which give the composition weight and unity.

fix the reality of life, Redon employed them to express the images of the subconscious, valuing it for its ethereal qualities as well as its clear, uncorrupted color. But he is probably best known for his ravishing flower studies, suffused with color and light.

Joan Miró (1893–1983) and Paul Klee (1879–1940) both used pastel in their abstract and semi-abstract work. Whereas Miró preferred the medium for its smooth blending qualities, Klee used it for heavily textured effects as a basis for his abstracts, frequently working over burlap or linen.

So many complex mixtures of media are used today that it is frequently difficult to identify them in a pastel painting.

What are the different chalk pastels available to the artist today?

There are many manufacturers of pastels; some have been making pastels for centuries. Most recently, manufacturers are making rectangular, chunky block pastels without paper wrappers. These are available individually or in small sets that have been conveniently arranged according to hue, value, or subject palette, such as landscape or portrait.

Soft pastels
These, like all pastels, are made from artists' pigment, which is finely ground and combined with titanium or zinc white or French chalk. This is mixed in turn with a weak solution of gum tragacanth or gum arabic.

Hard pastels
These are made from the same pigment but contain more gum binder, and are combined with black pigment instead of the white chalk used in soft pastels. The harder sticks that result are capable of being shaped or sharpened and used for fine lines and detail. Because of the admixture of black, the color appears denser and darker and does not have the luminosity and bloom that is associated with the soft pastel.

Pastel pencils
These are simply pastels encased in wood. They are both delicate and expensive, and shatter easily. They must be carefully sharpened or sanded to a point. Pastel pencils are useful for detailed work and can be used for drawing. They are ideal for use with watercolor, where they can pick out detail and give a charming effect on slightly damp paper.

What do soft chalk pastels look like?

Soft pastels are made in cylindrical sticks or rectangular cubes, the diameter varying with the brand.

Half-length sticks

Above: *These short sticks cost less than the full-length ones and are made especially for beginners. They are less prone to breakage, so they are sold without wrappers.*

Right: *For those who like to work on a large scale and prefer broad effects to fine detail, these cigar-shaped pastels are ideal.*

Soft pastel sticks

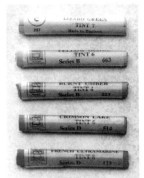

Left: *The paper wrappers on some pastels protect your hands from dust as well as making the sticks less likely to break. As you wear down the point, tear off a little of the paper at the tip. Keep the wrapper and a small piece of the pastel for reordering a color.*

Rectangular pastels

Right: *Rectangular pastels offer sharp edges for fine, straight lines.*

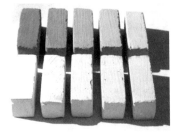

Chunky pastels

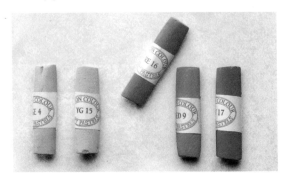

Why is soft pastel such a popular medium?

The loose, grainy texture of soft pastels provides great color clarity, but it is also the reason why many people find pastels difficult to use. The powdery color can seem to spread uncontrollably, and it is aggravating when a fragile pastel stick snaps or crumbles in the middle of a stroke. This can lead to a cautious approach, but the best results come from working freely and decisively.

Since the degree of softness varies noticeably from one brand of pastel to another, try out individual sticks from different manufacturers and compare their relative durability until you find the one that suits you best.

Soft pastels contain very little binder or hardening agent and proportionally more pigment. Color is rich, vibrant, and velvety. Soft pastels vary considerably according to the manufacturer, with some brands classified as soft being harder than others.

With experience, you will discover which type you like best. All brands are compatible with one another.

Can I tell a hard pastel from a soft one just by looking?

Hard pastels are usually rectangular and square-sectioned.

Below: *Not all pastel painters include hard pastels in their equipment, but hard pastels are useful for blocking in at early stages and for applying finishing touches.*

Why would I want to use hard pastels?

Hard pastels do not have such wide potential for varied surface effects because of the greater proportion of binder.

Hard pastels are the drawing medium that complements soft pastels as a painting medium. The color range is quite limited by comparison with soft pastels, with nothing like the degrees of variation in hue and tone. You can exploit the linear qualities by using the section edge of the stick, or even sharpening it to a point by shaving it with a fine blade.

What are pastel pencils?

Pastel pencils—softer than hard pastels but harder than soft ones—are often used for making a preliminary drawing as well as for adding touches of detail.

Pastel pencils are thin pastel sticks encased in wood, just like normal pencils. They are more expensive to buy, but it is a good idea to always have a few on hand because they are ideal for subjects that entail intricate work. Pastel pencils can be sharpened to a point, using sandpaper or a craft knife, to produce extremely fine, crisp lines. Because of their length and resistance to snapping or crumbling, pastel pencils give you greater control of handling and are excellent for techniques such as crosshatching and feathering. Another advantage, of course, is that your fingers stay clean!

Below: Pastel pencils are good for sharpening blurred edges. Do not drop pastel pencils because the pastel within the wood casing will break. Never draw with an ordinary graphite pencil, because you cannot easily cover the marks with pastel.

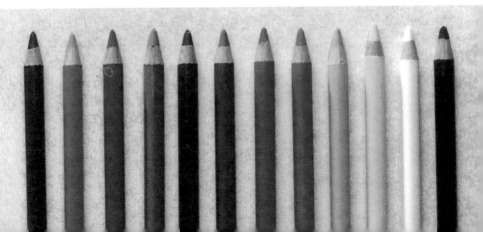

What are water-soluble pastels?

The wax content of these color sticks gives them a slightly moist texture, so they handle rather like oil pastels when you use them for drawn strokes. But brush over the color with clean water, and it instantly dissolves into an even, semi-transparent wash. The quality of the wet color is like a coarse watercolor wash, and you can vary it considerably according to the amount of water that you add. The restricted color range is composed of strong, unsubtle hues, but with the potential fluidity of the medium you have more scope for mixing and blending colors on the working surface.

What are oil pastels?

This medium is unique among the pastel types, containing an oil binder that makes the texture dense and greasy and the colors slightly less opaque than soft pastels. Typically, the colors are quite strong and the variation of color values is restricted.

The moist texture of oil pastel can quickly fill the grain of the paper, so the capacity to work one color over another is somewhat limited, but for painting effects, oil pastel marks can be softened and spread by brushing them with turpentine or white spirit.

Why are there so many colors of soft pastels available?

The main differences between pastels and paints is that you cannot premix colors—any mixing has to be done by laying one color over another on the painting surface. For this reason, manufacturers produce large ranges of colors and tints, that is, light and dark versions of the same color. Tints are made by adding white to the pure pigment for the pale tones and black for the dark ones; therefore, if you want the color in its purest form, look for a middle number.

Nearly all pastel colors come in different tones—that is, darker or lighter gradations of each individual hue. These tones, called "tints" or "shades" by manufacturers, are denoted in different ways. Some number them from 1 to 10,

the lowest number indicating the lightest tint and the highest one the darkest. Again, you will quickly get used to choosing by eye.

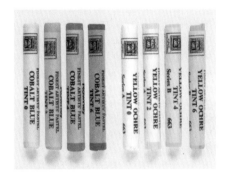

Four tints of cobalt blue **Four tints of yellow ochre**

Do all the brands of soft and hard pastels use the same color names?

Color ranges differ from one brand to another, and so do the names of the colors, which can be confusing. Some pastels are straightforwardly named according to the pigment—for example, "ultramarine blue" or "cadmium red." Others have more fanciful names, such as "glowing ruby red." If you are selecting

colors from a wide range, or combining colors from several manufacturers, you may have to choose by eye, which you will find easy as you gain experience. It is also fun—there is nothing more enticing to an artist than a drawer full of richly colored pastel sticks crying out to be used.

Can you recommend the colors of pastel a beginner should use?

Pastels are made in a huge range of colors—some manufacturers produce over 200—but you can start with 20 to 30, adding more as you need them. But how do you know which colors to buy? A good rule of thumb is that you will need at least two versions of each of the primary colors (red, yellow, and blue), three or four greens and browns, two different grays, a white, and a black. Our recommended palette, with 26 colors, also has an orange, a violet, and a purple.

Right: *The 26 colors shown here provide a range of values suitable for most subjects. Of course, you can add more as you need them.*

Crimson lake No. 6

Cadmium red No. 6

Cadmium tangerine No. 4

Yellow ochre No. 6

Ultramarine blue No. 6

Yellow ochre No. 2

Ultramarine blue No. 1

Cadmium yellow No. 4

Prussian blue No. 3

Lemon yellow No. 6

Cerulean blue No. 4

Olive green No. 8

Purple No. 6

Hooker's green No. 3

Violet No. 2

Hooker's green No. 1

Sap green No. 5

Lizard green No. 3

Green-gray No. 1

Blue-gray No. 4

Cool gray No. 4

Burnt umber No. 8

Raw umber No. 6

Burnt sienna No. 4

Silver white

Lamp black

Do pastels come in sets?

Most pastel
manufacturers
produce starter
sets of between
12 and 20
colors. These
are adequate
for early
experiments,
and you can buy
more colors as
single sticks once
you begin to
work seriously.

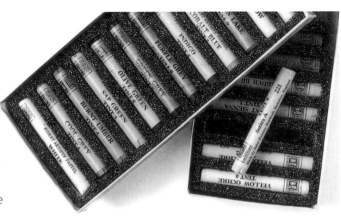

What is an inventory color chart?

Sooner or later you will have to replace some of
your colors, and by the time the pastel stick is
worn down to a stub, you will almost certainly
have lost its wrapper. How then will you
know which color to take from the drawer
in the art store? It is no good trying to
guess; instead, be methodical and
compile a color chart as soon as you
have made your initial purchase.

Right: *Apply a sample of each color,
with the name of the manufacturer
and tint name and number
underneath. Pin the chart up
on the wall or keep it in a ring
binder or a small spiral-bound
sketchbook.*

Cerulean blue No. 4

Lemon yellow No. 6

Ultramarine blue No. 1

Hooker's green No. 3

Violet No. 2

Hooker's green No. 1

Blue-gray No. 4

Gre

How do I store my pastels?

A boxed set of pastels contains a tray of preformed slots where you can place your sticks after each working session. But if you choose a starter palette of loose pastels, it makes sense to consider ways of organizing the pastels neatly and keeping them separated so that they remain clean. You can buy special boxes for loose pastels but these are expensive. You can save money by using your ingenuity. For example, corrugated cardboard is ideal for separating pastels, and you can use it to line the small oblong cardboard boxes that manufacturers use to package their pastels and tubes of paint.

As you build up your collection of sticks, you will need a larger container, so keep your eyes open for a long, flat box with a secure lid. If you have no corrugated cardboard, you could line the box with ground rice. This not only cushions the pastels but also helps to keep them clean, because the rice absorbs the dust that always collects on the surface of the sticks.

Above: *Safe storage. Corrugated cardboard holds the sticks firmly in individual grooves, so that they remain clean, easy to select, and less likely to break.*

Can I make my own pastels?

In the past, artists always prepared their own materials, a skill which is unfortunately underrated in modern art schools. The sense of satisfaction derived from the discovery of a new color or technique comes through the diaries and memoirs of past artists and craftsmen, from Albrecht Dürer, recording his delight in making a particular shade of blue, to J.M.W. Turner, arguing with his housekeeper over the mean amount of blue she habitually put out when arranging his palette.

There are very good reasons for learning how to make your own pastels. The better you understand the structure

of the material you are working with, the better you will be able to maximize its potential.

The more expensive and extremely soft German and French pastels, important for laying techniques, are difficult to find except in specialized shops, though they are more readily available now because of the Internet. With a little practice, you should be able to make your own satisfactory substitute. In addition, you will be able to make your own range of colors—those you would buy if using paints. For example, if you are sketching a landscape, you can make a better selection of greens than is available in the manufactured range.

Pastel is a medium that calls for a large range of colors, which you can extend by personal experimentation.

Above: *There is nothing like actually creating your own tones to break down inhibitions and build confidence.*

What binders and pigments do I use when making my own pastels?

Many types of binding solution can be used; strained oatmeal gruel, for example, is a very light binder, suitable with pigments such as madder lake, Prussian blue, and cadmium red, which would tend to be quite hard if used with a gum binder. Gum arabic can make the sticks brittle, with a hard crust. The

brittleness can be reduced by adding honey or crystallized sugar. Skim milk, which provides a weak binding medium, can also be used.

The best binding solution is gum tragacanth. 46.29 grains (3 grams) is added to 2 pints (1 liter) of water and allowed to stand until a jelly is formed.

This should be warmed slightly until it becomes a paste. If there is difficulty dissolving the tragacanth, add a small amount of pure alcohol at the outset. A quarter of a teaspoon of beta naphthol, available from specialist suppliers, can be added to the binding solution to preserve it in good condition for storage.

Most artist's pigments are suitable with the exception of Cremnetz white (or flake white), Naples yellow, chrome yellow, and emerald green. Breathing in the dust of these colors, especially the latter, can be quite dangerous.

When starting off, it is best to use a small amount of solution and to make only a few sticks at a time so that you can check your results. If the pastels are too hard, more water can be added to the mixture, and if too soft and crumbly, a small amount of gum can be used to firm up the original solution.

How do I clean my pastels?

However carefully you store your pastels, it is difficult to keep them clean when you are working. Eventually, they will become dirty, because pastel dust on your hands will be transferred to a previously clean stick. They can be cleaned easily with ground rice or a similar grain, such as semolina.

Cleaning Pastels

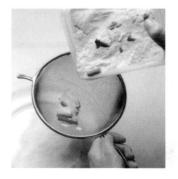

1 Put your dirty pastels into a container full of ground rice and shake them gently until all the muddy-colored dust has been absorbed by the grain.

2 Empty the contents of the container into a colander and shake well to strain off the rice. Your pastels should now be clean.

Can you show me the method for making my own pastels?

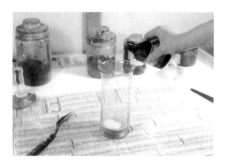

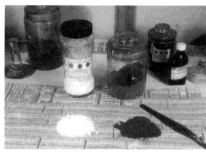

1 Begin by carefully preparing the gum mixture as described on page 22 in the answer to the question: *What binders and pigments do I use when making my own pastels?*

2 Place two equal piles, one of pigment and the other of zinc white, on a piece of newspaper. The piles can be mixed easily by slightly lifting the edges of the paper and rolling the two pigments together.

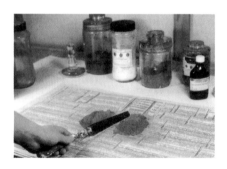

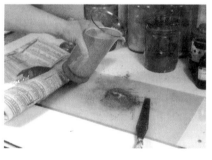

3 Next, place the mixture on glass or paper and divide it in half. One half is used to make the color while the other part is retained to make graduated tones by adding more white.

4 Add the gum mixture very slowly and mix with a palette knife after each addition of gum to form a thick paste.

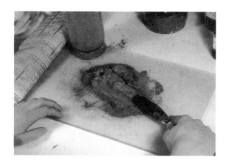 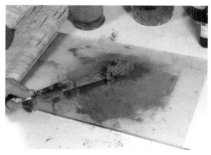

5 Mix thoroughly with the palette knife. Allow the mixture to rest for a short period of time so that the pigment can absorb the solution thoroughly and soften.

6 When the mixture is ready, collect some of it on the palette knife and roughly shape it into a stick.

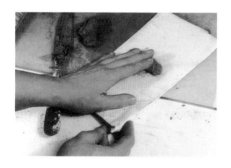 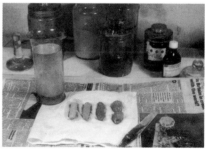

7 Put this on a piece of paper towel, and roll it into the finished shape. Make pastels thicker than manufactured ones to give them additional strength.

8 The completed sticks are then laid out on paper towels and left to dry naturally for about 48 hours.

CHAPTER

2

WORKING WITH PASTELS

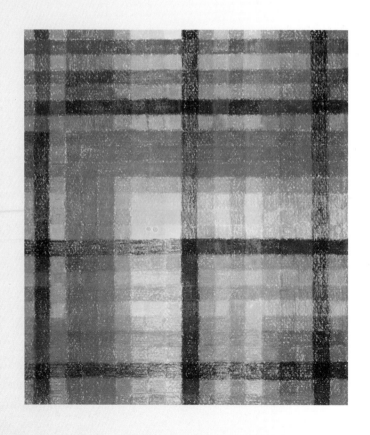

What are the guidelines when choosing a support/surface for pastel work?

Texture is a vital part of pastel work, and so the choice of surface is critical to the success of the finished picture. The smoother surfaces allow you to blend the colors smoothly and evenly, while rougher ones provide a vigor and sparkle that may suit your purposes better. If you want a smooth surface, cardboard is better than paper because it is rigid and there is less chance of the pastel flaking or dropping off. A smooth, flexible surface constantly loses pastel because the shallow grain of the paper will not grip and hold a solid layer of pigment. The more the surface flexes, the more pastel is likely to drop off.

You can experiment with any type of paper or cardboard, but try to use paper with a rag content or one that is acid-free. Paper with a large wood-pulp content, or ones that have been heavily bleached during manufacture, will disintegrate with time. The pastel pigments themselves are permanent.

Can you tell me some brands of paper and their attributes?

Pastel papers are manufactured with a slight "tooth," or texture, which "bites" the powdery pigment and holds it in place. Sanded paper is available in different grades from very coarse to very fine and is popular with pastel painters—usually the finer ones are chosen.

There are many types of paper made especially for pastel work. The two best-known and most readily available are Ingres paper and Canson Mi-Teintes.

The first has a pattern of straight lines, while the texture of the second resembles fine chicken wire. But Mi-Teintes is effectively two papers in one, as you can use the smoother side if you prefer—it has a less obtrusive texture but it still holds the pastel.

Another popular paper is Wallis, a sanded paper known for its extreme durability.

Why do so many artists start with colored paper for a pastel painting?

The reason for working on colored papers is simple and practical. As we have seen, pastel papers have a surface texture, so unless the color is applied very heavily, it is virtually impossible to cover the paper completely. The color sits on top of the raised texture, and there are always flecks and patches of naked paper showing between and around the strokes.

Pastel is a partnership between pigment and paper, and if the color of the paper is chosen with care, it enhances the work. In many pictures, large areas of paper are deliberately left uncovered. Landscapes are often done on blue or blue-gray paper, with the sky left as the paper color. In portraits, the face and figure may be worked in pastel, while the background consists entirely or almost entirely of the paper color, perhaps with a few light strokes to suggest furniture or a window frame to give a context to the figure in the foreground.

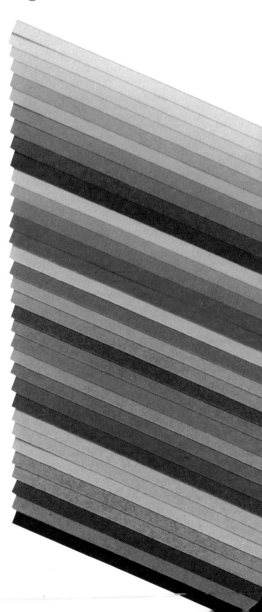

ARTIST'S TIP
When you find a paper you love, you may have the urge to "stock up." Instead, try different surfaces occasionally because, with experience, your strokes and pressure may change and another paper might better suit you in the future.

It seems to me that the pastel color would be affected by the color of the paper. Is this true?

These charts show six colors (pale yellow ochre, pale ultramarine blue, crimson lake, Hooker's green, lizard green, and raw umber) on three different paper colors. Even these neutral papers significantly affect the appearance of the first colors applied to them; the yellow virtually disappears on the cream paper, so you would need to begin with the darker colors, leaving the pale ones until you have established the hues against which to judge them.

The effect of paper color

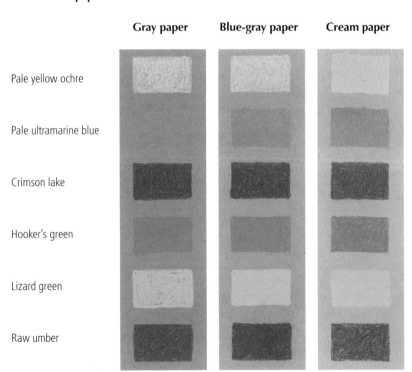

	Gray paper	Blue-gray paper	Cream paper
Pale yellow ochre			
Pale ultramarine blue			
Crimson lake			
Hooker's green			
Lizard green			
Raw umber			

Gray paper

This paper is substantially darker than the others, showing the yellow well. The three mid-toned colors—blue, light green, and raw umber—look much paler than they do on the second paper.

Blue-gray paper

The blue bias of this paper shows the yellow and greens to advantage. It is a popular choice for landscapes, because areas can be reserved for sky and for highlights on foliage.

Cream paper

The darker colors, such as the red and deep green, show up well on the light paper, while the raw umber looks darker than on the other papers.

Can I use the paper color as the background of my painting without adding pastel to that area?

Right: Over The Jump by Judy Martin

An open, linear style has been used to draw the horse and rider, beginning with free outlines that are gradually reworked to refine the shapes. The color of the paper gives a coherent background to the rapidly laid marks. Broader sweeps of color are added with side strokes and loose hatching to give the image a sense of depth and solid form.

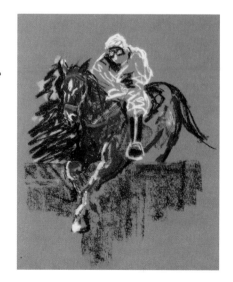

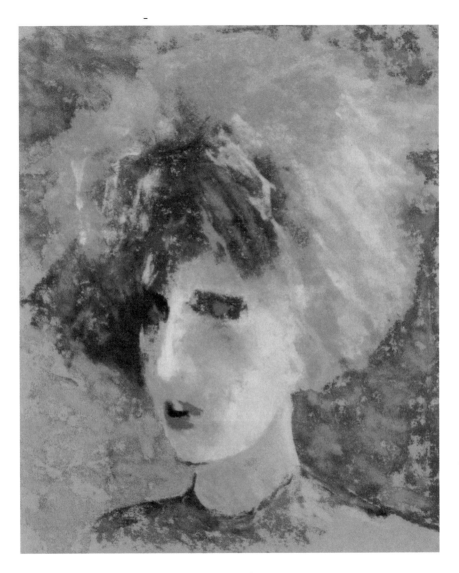

Above: Portrait of a young woman by Diana Constance *In this painting, the color of the paper shows throughout the painting but it makes an especially interesting background because of the way the pastel was applied there.*

What are the good things and the drawbacks when starting with white paper?

If you start with white paper, you can tint it any color you want.

When working on a white surface it is hard to assess the first colors you put on. Since everything looks dark against white, you may find that you begin with colors that are much too pale, setting a wrong color key for the picture.

Laying an all-over tint

If you like to work on watercolor paper, you will normally need to tint it in advance, because otherwise you will find distracting flecks of white appearing through your pastel strokes. You can color the paper with watercolor or thinned acrylic paint, using a large, soft brush to lay an even wash of color to create the desired effect.

Alternatively, you can use ground-up pastel color to lay a "dry wash." To do this, peel some of the paper off one of your pastel sticks, or use a broken one. Hold the stick above a saucer and scrape it gently with a knife to make colored dust. Then dip a rag or cotton ball into the powder and rub it across the paper, pushing it well into the grain.

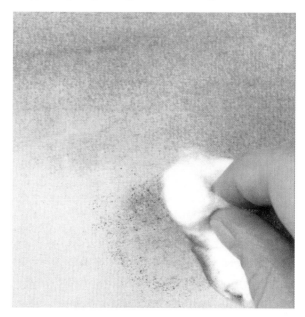

Right: *Create your own colored tint background by laying a "dry wash."*

I hear a lot about paper texture or "tooth." Does pastel paper come in different textures?

Texture ranges
This photograph shows the two standard pastel papers and some more specialized ones. The chart on the opposite page demonstrates how the pastel behaves on the different textures.

Ingres paper

Mi-Teintes paper

Artists' sandpaper

Pastel board

Watercolor paper,
medium surface
(cold-pressed)

Does the pastel behave differently on different textures?

If you work on one of the thinner papers, you may find that blemishes can be caused by the slightest scratches or bumps in the drawing board. Cushion your painting surface by putting several sheets of paper beneath it.

Finding the best surface

It often takes time to discover which paper best suits your way of working. This at-a-glance chart offers some suggestions, but it is a good idea to experiment, starting with the less expensive papers made especially for pastel work.

Ingres paper
Lines show through the pastel unless very heavily applied.

Mi-Teintes paper
Lines show through the pastel unless very heavily applied.

Mi-Teintes "wrong" side
Smoother but with enough texture to hold the pastel.

Artists' sandpaper
Grips color well; is suitable for detail, as it does not break up the strokes.

Artists' sanded paper
Breaks up strokes; not suitable for fine lines or detail.

Velour paper
Pastel sinks into the surface, so that the edges of strokes are softened.

Pastel board
Grips pastel well, allowing one color to be laid thickly over another.

Watercolor paper
Heavy texture; pastel "sits" on top of grain unless pushed in during application.

What are the things I should consider when choosing my pastel surface?

The term "support" refers to the ground used for the drawing, whether this is paper, board, or fabric. Texture is a vital part of pastel work, and so the choice of surface is critical to the success of the finished picture.

You should first consider your subject and the mood you want to capture. A subtle study of flowers, for instance, with delicate, smooth petals and bright color, may require a completely different support to the one you might choose for a windswept landscape or a busy cityscape. The smoother surfaces allow you to blend the colors smoothly and evenly, while rougher ones provide a vigor and sparkle that may suit your artistic purposes better.

How can I utilize textured canvas?

Right: Illuminated Barn by C. Murtha Henkel *The impression of weather-worn wood was made by dragging white pastel over the darker colors just enough to catch on the tooth of the textured ground.*

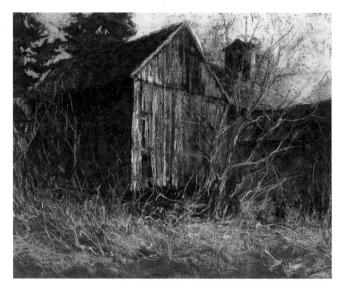

I want a really bold statement. Will black paper help create a dramatic painting?

The sun creates shadows, which present compositional possibilities. Evening light is often best, making shadows longer and colors richer.

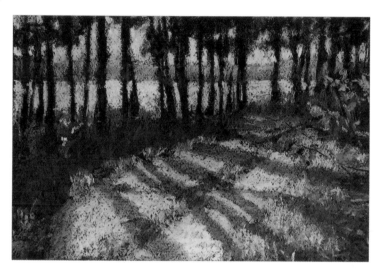

Above: Cove At Dusk by Rosalie Nadeau This wonderful impression of sunset colors uses violet and yellow complementary contrasts to enhance the effect of the diagonal shadows leading to the dark verticals of the trees. To set the tonal key for the painting, the artist made the obvious choice of black paper, working up from the darkest to the lightest colors.

Setting sun illuminates the water and silhouettes the trees.

Bright highlights and patches of vivid color where sun strikes foliage.

Flecks of black paper show, toning colors down slightly.

Can I make my own pastel surface?

All pastel papers have some texture because this is necessary for holding the pigment in place, and there are various different papers to choose from. However, you can exploit texture in a more dramatic way by laying your own textured ground.

Textured ground

To create this textured ground, you will need acrylic paint or a substance called acrylic gesso (a combination of chalk, pigment and plastic binder), along with a heavy watercolor paper or a piece of board, such as mounting board. Put on the paint or gesso with an artist's bristle brush or ordinary paintbrush, aiming for a slightly uneven, striated look. When you lay pastel on top of this ground, you will find that the color catches on the small ridges, creating intriguing effects. It takes a little practice to discover how the method can be used best, but this is essentially a try-and-see technique.

You can also create a surface similar to artists' sandpaper by scattering pumice powder onto hardboard or mounting board. You will need to lay a coat of adhesive first. This could be either glue, wallpaper paste, or acrylic medium. When the surface has dried, it can be colored with thinned acrylic or watercolor paint.

Acrylic gesso ground

1 Unless you want to work on a white surface, tint the gesso by mixing it with a neutral acrylic paint. This method is quick because there is only one layer to dry. However, you could apply the gesso first and then tint it.

2 Using a bristle brush, paint the colored gesso all over a piece of heavy watercolor paper. Aim for an uneven effect, because you want the striated texture of the brushstrokes to show through the pastel. Allow to dry.

I work in a small space; do I really need an easel?

If you don't have an easel, you can attach your work to a wall.

Below: *When working at an easel, the best position is with the board upright. This allows excess pastel dust to drop off the painting. Step back to assess your work from a distance; you cannot judge it properly if you are too close.*

What other equipment or tools do I need for painting in the studio with pastel?

One of the many attractions of pastel work is that you do not need much equipment; the basic requirements are pastels and paper. However, there are a few additional items that you may find useful.

Craft knife
A craft knife is useful for sharpening pastel pencils and for cutting paper.

Bulldog clips
Bulldog clips can be used for holding paper on a thin drawing board, such as plywood or hardboard.

Brushes
Brushes are not essential, but are useful for blending and for flicking off excess pastel.

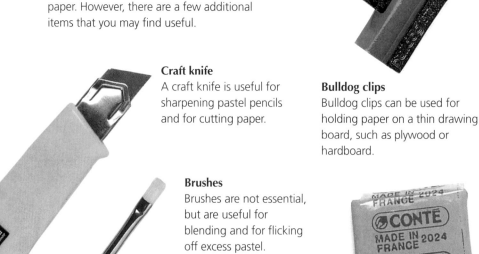

Kneaded eraser
These are useful because they can be pinched into a small point to lift pastel from small areas.

Fixative
Fixative comes in aerosol spray cans or spray-pump bottles.

Tortillons

Tortillons are narrow tubes of rolled blotting paper used for blending colors. You can use your fingertip just as easily, but tortillons (also called torchons) are rigid and pointed at the tip, making them good for small, detailed areas. They also minimize the risk of grease from your skin spoiling the painting.

Cotton swabs

Cotton swabs are an inexpensive alternative to tortillons.

Absorbent cotton

Cotton is good for large-scale blending, but not on sanded paper.

Protecting the floor

Even an uncarpeted floor needs protection while you work, because pastel dust flies around if you try to sweep it up. Put an old sheet or plastic dustsheet under your easel. Gather it up and shake it outside gently when you have finished working.

Masking tape

For fastening large sheets of paper to the drawing board, masking tape is better than bulldog clips.

Rags

Rags or paper towels for cleaning your hands periodically are essential—pastel is a messy medium. Rags are also useful for blending.

Are pastels messy to work with?

As soon as you start to use your pastel sticks, you will discover that pastel is a messy medium. Colored dust falls onto any nearby surface, your hands become covered with it, and perfect new pastel sticks acquire a muddy coating from jostling with other colors lying next to them on your work table.

You can clean your pastels with ground rice (as explained on page 23), but you will not want to do this too often, so you should try to keep the sticks clean while you are working. This means training yourself to be methodical.

When you are in a hurry to get something down on paper, it is natural to pick up a new color before putting the previous one back in the container; after a while you may find yourself with a handful of colors. But however natural the habit, it is not wise. A better practice is to make an improvised palette to hold the colors you are using at any one time and to which you can return the pastels systematically. A length of corrugated cardboard is ideal for the purpose (see illustration on page 21), and so is a tin dish filled with ground rice.

Right: *To keep your pastels clean, line a box or dish with ground rice and make it your palette for the pastels you use during a working session. Replace each stick before you pick up a new color; this will keep the sticks clean and avoid breakage.*

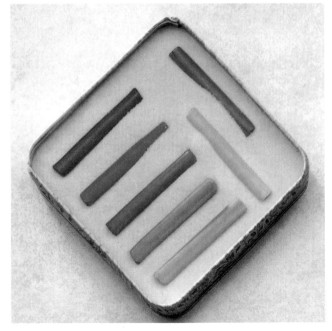

How can I keep my hand off my paper while working?

Using a mahl stick
A solution is to use a mahl stick, which you can make by padding one end of a piece of cane or dowel. This keeps your hand away from the paper and gives better control for details.

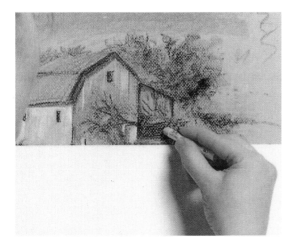

Avoid smearing
It is easy to smear completed areas of a painting with your hand. If you are working at the top of the picture, cover the lower parts with a sheet of clean paper.

How can I keep my hands clean?

Your hands will become soiled from the pastel sticks, so keep a damp rag close by for periodic cleaning.

Right: *For your work area, you will need a surface of convenient height to set out your materials within easy reach. This could be a small table or a board on top of a stool. Keep a damp rag there so that you can clean your hands when necessary.*

Why do artists break pastel sticks in half or into small pieces?

Pastels can be sharpened with a knife, but the point will quickly wear down. Fine lines can be achieved by using the edge of the pastel stick, or making a new edge by breaking one of the sticks in half.

Below: *If this is your only stick of a particular color, put half of it away, labelled with its brand and color number or swatch so you can match it when you need to purchase another.*

Are there health concerns when using pastel?

If you blend color with your fingers on a sanded surface, be sure to wear latex or nitrile gloves to protect your skin from abrasion. For general protection use an artist's barrier cream.

Place a gutter under your painting to catch excess pastel dust. You can make a simple one from aluminum foil.

Don't blow excess pastel dust from your painting. Take it outside and tap the back of the painting to remove excess pastel before framing.

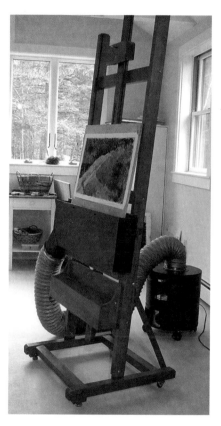

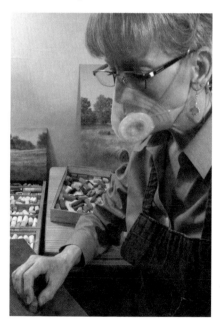

Above: *An air cleaning system that collects and filters dust, solvents, and other toxins.*

Left: *If you don't have an air filter, it is advisable to wear a protective mask.*

If I collect the excess pastel dust that falls from my painting or if I grind up very small pieces, can I recycle the powder into a new pastel stick?

If you use a gutter to catch the excess pastel dust (all colors mixed together) from your paintings, you can pour the dust from the gutter onto a glass surface, add water and mix it thoroughly with a palette knife to the consistency of stiff peanut butter.

Next, spray a clean area of the glass with water and lay down a piece of plastic wrap (the water keeps the wrap from moving around). Scoop up the pastel-blob with the palette knife and plop it onto the wrap. Pick up two opposing edges of the wrap and roll the blob side-to-side to form a little log. Leave it on the plastic wrap to dry.

Below left and right: *Compare the new color you have created to similar colors you have purchased. Your handmade color will be unique.*

I love the way my new pastels look with their paper wrappers. Why should I remove the wrapping?

A pastel with a paper wrapping can be used only for marks made with the end of the pastel. Break the stick in half and store the half with the identifying number, color, and brand for when you need to reorder that color.

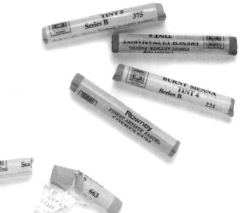

Right: *Pastel sticks that are still in their wrappers have limited stroke options. Unwrap them so that you are able to use the side as well as the end to create various effects.*

How should I organize my pastels before I start painting with them?

Organizing your pastel sticks will greatly increase your chances of finding the exact color you have in mind instead of settling for a color that is "close enough" to what you really want.

Separating soft and hard pastels is the first step; then arrange by color and value. Using this method, when a pastel stick rubs against its neighbor, the resulting color transfer will be close enough in value and color to ensure that it won't have to be cleaned before you use it.

Above: *These small "flat files" are a good way to store your hard pastels. Keep the boxes near your easel for easy access.*

Right: *Keep soft pastels beside your easel in open boxes or trays so all colors are visible. Group neutrals together.*

Why should I take time to do a color study before beginning a painting?

A small color study will help to narrow down the colors to be used in a painting as well as helping you to navigate compositional concerns.

Below: *Keep the small color study close to you as you work on a larger painting.*

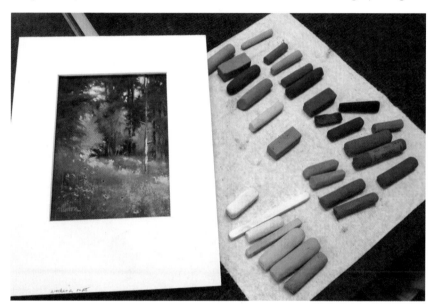

What should I do if the colors in my painting look muddy?

Mud is usually created when a painting becomes overworked or the artist did not start with a clear vision for the painting. Try lifting or brushing off some color to begin again. Once you make mud, you will appreciate the suggestion to make a small color study (*see* above) before you begin to help clarify your vision for your painting. Time spent in preparation is well spent.

How do I use neutral colors in a painting?

The neutral colors—the grays and beiges that are often hard to give a name to—are a powerful ally in setting up contrasts, as they help to make brighter colors sparkle. But choose these colors carefully because none of them are really neutral. They all have a slight color bias—a gray can be greenish, bluish, or tend toward violet. You could bring in a touch of complementary contrast by setting bright red against a greenish gray, yellow against violet-gray, or green against reddish-brown.

There are only three genuinely neutral colors: black, white, and gray made from a mixture of the two. A color with any kind of bias will be affected by surrounding colors; these "swatches" show how two grays behave in different circumstances.

Neutrals in context

Against red and orange, gray-green appears neutral.

Against a genuinely neutral gray, made from black and white, gray-green becomes positive.

Purplish gray is much less vivid than blue and pink.

Similarly, the purplish bias of this gray shows up as color against genuinely neutral gray.

What is working from life?

A majority of art teachers will agree that the most valuable early experience lies in painting directly from the real world. There is a good reason for this. Painting is a translating activity. You are creating an illusion of the three-dimensional world on the two dimensions of a piece of paper, and you have to figure out how best to do this. A photograph has already reduced the world to two dimensions, which might seem to make your task easier but in fact does not always do so. The camera may not carry out this initial "translation" in a way that you as an artist might do, so it may rob you of more creative options.

Bear in mind that the picture you are making is not just a copy of something in the real world; it has its own independent existence as an artwork.

What does the term "painting plein air" mean?

This is a French expression which means "in the open air." It is used to describe the act of painting an outdoor scene while actually being there.

I would like to try a plein air painting. What do I need to know before I begin?

The first step is to organize the expedition. It is wise to take a camping stool as sitting on the ground limits your viewpoint and can be an uncomfortable posture. You'll need an easel, a board with clips, or tape to hold your paper. Other considerations are drinking water, bug repellent, an umbrella to shade against bright sun or protect from rain, and of course adequate protection for transporting your pastels even if you are using a limited palette for travel.

Is art made with pastel a drawing or a painting?

When pastel is applied in a "painterly manner," that is, using the side of the pastel to lay in broad areas of color, the complete surface of the paper becomes covered and the resulting artwork is thought of as a painting. When strokes are more linear and sketchy, leaving some or most of the paper surface unmarked, the finished piece of work may be referred to as a drawing.

Left: Slave Girl, study for The Death Of Sardanapalus by Eugène Delacroix, 1798–1863, Louvre, Paris *This work has characteristics of both a painting and a drawing.*

Opposite: Head of King Louis XV by François Lemoyne,1688–1737, The J. Paul Getty Museum, Los Angeles *Lemoyne specialized in decorating ceilings on a monumental scale, and this black chalk and pastel drawing on faded blue paper was done as a preparatory study for the allegorical painting Louis XV Bestows Peace upon Europe. Fine strokes of black chalk create the young king's gently curling hair, while delicate lines of pastel give soft highlights to his hair, eyes, nose, and pursed lips. We can see from the foreshortening of the head that it was meant to be viewed from below.*

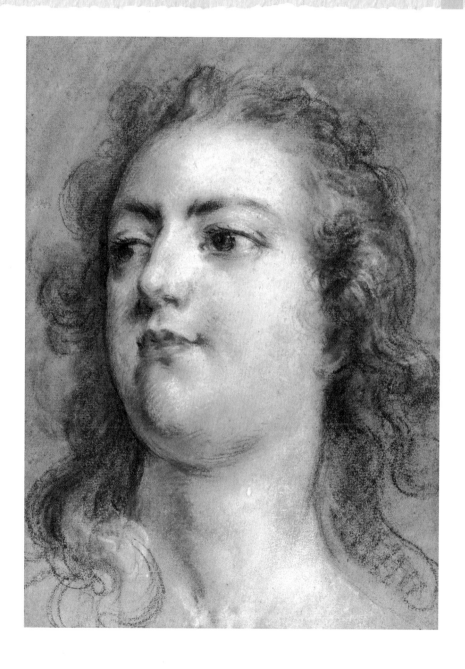

What is a vignette?

When an artist finds they have achieved their goal for a painting—such as creating a likeness in a portrait—they may choose to stop painting and leave the sketch with a fresh or "in progress" look. This is called a vignette. It occurs when the edges of the painted area fade into the surrounding paper.

Right: Preliminary sketch for Portrait Of John Bowman by Diana Constance *Here, the artist has created a vignette by not adding any detail to her subject's neck or shoulders*

Should I use a fixative when my pastel painting is complete?

To fix or not to fix? This is the question that causes more controversy among pastel artists than any other.

Keep in mind that there are workable fixatives to use between layers of pastel and final fixatives that are used when the painting is complete. Some artists never use a fixative, even when their painting is finished.

The brilliance and fragility of the pigment particles clinging to the working surface are regarded by some artists as

essential characteristics of pastel work. Fixatives may be considered to degrade both the color and texture of soft pastels. However, careful fixing need not spoil the surface qualities, and you may feel that any disadvantages are offset by the protection that fixative gives to your work, both during its stages of development and when it is finished.

The key to successful fixing is to use the fixative sparingly. Overwetting the surface can cause the pigment particles to merge, muddying the texture; it can encourage strong colors to bleed through overlying tints; and it does tend to darken colors slightly. But if you apply a light layer of fixative at successive stages of the drawing, it enables you to overwork colors freely and keep the hues, tones, and individual marks distinct and clean. Fixing again when the work is finished prevents accidental smudging, powdering, or flaking.

If you are working on a light- or medium-weight support, you can spray the fixative onto the back of the paper. It will penetrate enough to gently dampen the pastel and make it more secure. If you definitely prefer to do without fixative, try fixing the surface of a finished work by laying a sheet of glassine or tissue paper over it and applying even pressure to push the pastel particles a little more firmly into the paper grain.

Aerosol cans of fixative are convenient and are usually now environmentally friendly. Some artists still prefer using a mouth diffuser spray to apply fixative from a bottle, but you do get a more reliably even spray from an aerosol.

Below: *Make a quick test spray first to check that the nozzle is clear and the spray quality even. Hold the can about 12 inches (30 cm) from the paper and spray from side to side, covering the whole area. Avoid overspraying, as this wets the surface and may cause colors to run or mix.*

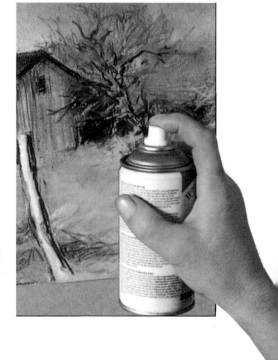

CHAPTER

3

PASTEL
TECHNIQUES

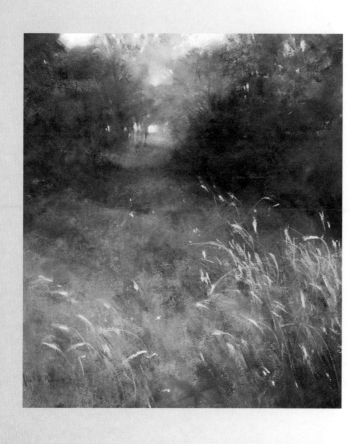

I have my new pastels in hand. Now, what are the basic techniques of this medium?

The marks you make with your sticks of color are the bricks and mortar of your pastel paintings. They can describe form and volume, convey texture, and create outline and detail. And, more than this, they are your personal handwriting, those individual characteristic marks that make your work different from that of any other artist.

The more you can practice, the better. You will gain experience in handling pastels as well as build up a repertoire of marks. After a while you will know instinctively which ones to use in your paintings, just as the process of handwriting becomes so automatic that you no longer consider how each letter and word are formed.

What is the technique called line stroke?

The strokes made with the tip or edge of the pastel stick can be infinitely varied, so begin by doodling to see how many different ones you can achieve. Try long, light strokes; short, jabbing ones; curves and dots. Try making strokes that change from light to heavy or from fine to thick, depending upon the pressure you apply

and the angle at which you apply the pastel stick to the paper.

Experiment with ways of holding the pastel. For light strokes you can guide it loosely with your fingers near the top end. For short, dense marks requiring greater pressure, you will need to grip the stick near the drawing end.

Heavy pressure
Heavy pressure, with the pastel pushed into the paper grain, gives stronger color.

Light pressure
The lighter the pressure, the paler the color will look, as the pastel only partially covers the paper.

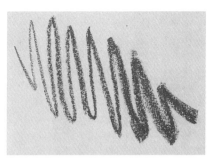

Above: *Try a range of squiggly marks made with a blunted point.*

Above: *Vary the stroke from thin to thick, starting with a sharp edge.*

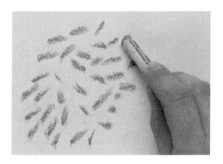

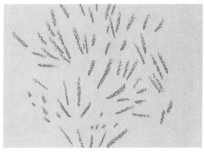

Above: *Make short, straight, jabbing strokes, holding the pastel near the end.*

Above: *Make short strokes with the sharp tip of the pastel.*

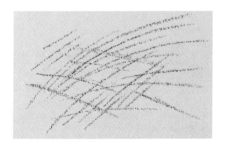

Above: *Use the edge of the stick to draw fine lines and long, sweeping strokes.*

Above: *Try several colors, making strokes that follow different directions and overlap.*

How is line stroke used in a pastel painting?

Rich textures are built up in a series of overlaid marks, carefully manipulated to describe the forms in terms of their component shapes and color relationships. In this drawing, the pastel strokes have a vertical emphasis, but sometimes marks follow the direction of the forms in order to emphasize a particular curve or angle. It is easier to control the overall image if the strokes follow one direction.

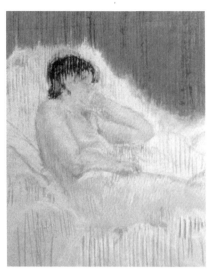

Right: *In the initial stages of the drawing use medium soft pastels, graduating to the soft type to develop texture as the drawing progresses slowly.*

Above: *Thin lines of pure color are laid down in directional strokes next to and on top of one another.*

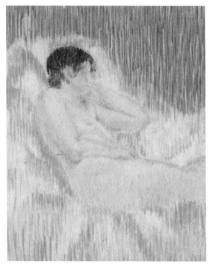

Right: *As seen in the finished picture, it is the combination of forceful, vertical strokes used to define a largely horizontal subject, which creates a harmonious, stable image.*

What are gestural strokes and when would I use them?

The essence of this technique is using rapid and uninhibited movements of the pastel to capture the immediate impression of a subject.

Gestural drawing relates particularly well to subjects that have movement—individuals or groups of people, animals, a windswept landscape, or a swelling sea. It is important to develop a free connection between what you observe and the way you translate it to paper, letting the motion of your hand and arm echo the rhythms of shape, contour, and direction. The spontaneity of the approach is lost if you become concerned with individual details.

Gestural drawing is very successful with soft pastels or oil pastels because they glide easily across the paper and provide a broad range of surface effects. Exploit your repertoire of linear marks and use loose side strokes to convey massed color or tone. If you work with hard pastels or pastel pencils, the

character of the medium suggests a more sketchy, linear style, using scribbled textures and roughly worked areas of hatching or crosshatching to represent volume and contour.

This method of working is good practice for anyone who tends to be timid or whose approach is overly tight and fussy. Removing the possibility of achieving fine detail can free you to focus on the key qualities of the subject.

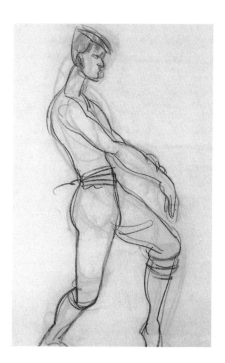

Right: T'ai Chi Exercise by George Cayford *Fluid contour lines capture the essence of the pose and also describe the roundness of the limbs and body, where the artist's hand lets the pastel tip flow easily around the forms. The movement sequence is described here using successive colors as elements of the pose slowly change.*

I know about crosshatching with a graphite pencil—can you show me crosshatching with pastel?

Crosshatching is the classic drawing technique in which tones are built up with lines criss-crossing each other in opposite directions.

Simply by varying the density of the strokes, you can create a wide range of tones; closely spaced lines with a dark pastel on a light-toned paper will create a dark tone, and widely spaced lines a light one, whereas for a light pastel used on a dark paper the opposite applies.

By interweaving different colors, you can achieve particularly vibrant color mixtures. Each hue retains its own identity, but blends partially with adjacent colors in the viewer's eye to create a new color that can be much more interesting than a single area of flat color. Also, the lines themselves have life and movement, adding considerably to the surface interest of the painting. For example, when crosshatching is used in a figure painting, it somehow conveys the impression of life more effectively than flat color does.

Crosshatching, as a linear technique, has an advantage over blending-in that dense, glowing color can be created without prematurely filling up the tooth of the paper, thus retaining a fresh, lively appearance to the work.

Above: *There is almost no end to the effects that can be achieved by altering the space and direction of crosshatched strokes. Here diagonal crosshatching has been used on top of vertical and horizontal strokes.*

Above: *In this example, the same strokes have been used, but in four different colors, which vastly extends the possibilities of the technique.*

Crosshatching works best on a smooth paper and can be used with all types of pastel, separately or in combination. However, hard pastels and pastel pencils are the most suitable for this technique because they give sharper, crisper lines. For even greater textural variety, the crosshatched lines can be softened partially in places by stroking them lightly with your thumb.

Crosshatching is normally done with diagonal strokes running in opposite directions, but you can also build up a denser web of color by running lines in several different directions—horizontal and vertical, then diagonally in both directions. Practice these techniques, and try different color mixtures on a variety of toned papers to see what effects you can create.

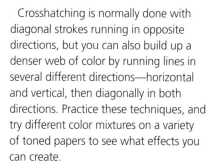

Above: *Create more variety by altering the pressure used so that some strokes are thicker than others.*

Above: *Here an interesting pattern has been formed by making several small groups of crosshatched strokes in different directions.*

Left: *Traditionally, hatched lines follow the contours of the object. In this simple still life, the lines describe the curved shapes of fruit and bowl, with straight lines emphasizing the flat plane of the tabletop. A limited range of colors is interwoven to create tonal variations giving depth and form.*

What is feathering and when would I use that technique?

The term "feathering" describes the technique—quick, light, linear strokes made with the tip of the pastel, keeping the direction of the strokes consistent.

Feathering couldn't be simpler. All it involves is making very light, feathery, strokes of one color over an area of previously laid, fixed flat color, so that the underlying color still shows through but is modified by the feathered strokes. For example, if a certain red looks too hot, you can tone it down by feathering over it with strokes of its complementary color, green. If you've painted an area gray and it looks dull and flat, liven it up with feathered strokes of yellow or red.

This technique works best with a hard pastel or pastel pencil. Soft pastel may smudge and cover the layer below too much. Don't press too hard—use a light, feathery touch to float the color on top of the existing one.

Below: Ihi At Aldeburgh by Geoff Marsters *Feathering is used very effectively here to enhance the atmospheric qualities of the image and create subtly vibrant color mixes.*

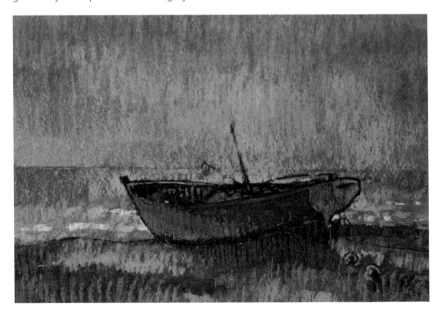

What is the pastel technique called side stroke and why would I use it?

Side strokes are useful for covering large areas. They are also one of the most expressive of all the pastel strokes, and many different effects can be created by varying the pressure of the pastel on the paper. Smooth papers are best for detailed work or fine lines, but because they have little tooth to hold the pastel particles, they quickly become clogged if too many layers are worked on top of one another.

Right: *Try a series of curves, following different directions and varying the pressure.*

Above: *When side strokes are used on rough paper, the grainy effect produced can be used to suggest specific textures, such as tree bark, woven fabric, or perhaps a pebbly beach.*

Can you show me how to make side strokes?

Take a piece of pastel .5 to 2 inches long, and rub it over the paper to create a flat side. Then try different directions of strokes—from long, straight, even ones to short curves—while applying different pressures.

You will see that a heavy pressure forces the pigment into the grain of the paper, while light pressure creates a veil of color on the surface. Pressure can be varied in a single stroke, creating a gradation from light to dark.

Heavy pressure
Heavy side strokes produce solid areas of color, with little of the paper showing through.

Light pressure
Light side strokes give a veil-like effect of pale, hazy color.

Can I combine different stroke techniques within the same painting?

Some artists use line strokes alone, and others only side strokes—blended or unblended—but most often the two are combined.

Right: *If you keep the side strokes fairly light, you can work over them with lines of the same or a different color, and similarly you can work over lines with judiciously applied side strokes.*

I've heard artists say they are layering or overlaying color. What exactly is that?

Overlaying is sometimes referred to as layering color. It is another way of combining colors that can add an exciting surface quality to your work. The ability to build up a picture in successive layers, each one revealing some of the underlying color, is one of the great attractions of pastel painting.

Use the side of the pastel stick to drift a veil of color over an area of the picture. This can be a good way of modifying a color that is too bright or too dark, or of producing subtle mixtures.

Below: Laundry Lights by Rosalie Nadeau *The luminous colors and painterly effect were achieved by using the sides of the pastel sticks in a series of layers. One color shines through another even on the dark house, and the sky is made lustrous by mingling pale greens and blues with delicate pinks. The very soft, absorbent paper has a fibrous surface that gives it an uneven tooth.*

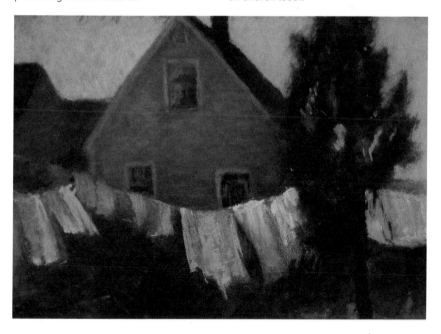

What is meant by the term "blending" when painting with pastel?

The powdery texture of pastel, which is one of the properties that can make pastel hard to handle, can also be used to your advantage.

Blending simply means rubbing one color into another and into the paper so that any lines are softened, and colors and tones merge with no perceptible boundaries. The technique is excellent for creating diffused effects—misty skies, for example—and for any areas of a painting that are intended to recede, such as the background of a portrait or still life.

Because it is so easy to create soft effects and mixed colors by blending, the method tends to be overused by beginners, and this can result in a bland picture. If you find this happening, use your blended areas as a base, spray the piece with fixative, and work over it with more energetic strokes, using soft or hard pastels.

I love the soft look of blending. Can I blend all my strokes or is it possible to overblend?

Overblending can make the work look somewhat dull, with a rather uniform texture. To correct this, give the work a good spray, leave it to dry for a few minutes, and then use a very soft pastel to go over some of the areas with an application of fresh color. Use a light touch to get a rough texture.

ARTIST'S TIP

Use a combination of blending and texture or detail to hold your viewer's attention. Smooth, blended passages of color give the eye a resting place, while bright, sharp detail and broken color slows or stops the path of observation as it moves around the painting.

How do I blend a large area of a painting?

For large areas, such as skies and water, it is best to lay on the color with the broad side of the pastel stick. When you have one or more colors applied to your surface, blend the color with a rag, paper towel, large brush, or preferably the fingertips, palm, or side of your gloved hand, since both rags and brushes remove color and create a lot of dust in the process. Pastel is more easily blended and pushed into the surface of the paper by hand.

Blending with a rag

1 Apply the first colors lightly, without pressing the pigment into the paper. Then brush over them with a rag. This removes some of the color, but you will add more as the work progresses.

2 Use the side of the pastel stick to lay darker color over the first blended ones. Again, avoid pressing too heavily. You should be able to see the grain of the paper through the marks.

3 Continue adding pastel and blending until you have the right depth of color. To enhance shapes, blend each one separately, drawing the rag along the shape rather than across it. Use the rag like a paintbrush or pastel stick to help you build up forms.

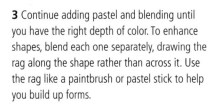

What is the technique for blending small areas with a tortillon?

When it comes to small areas that you need to control precisely, blend with a tortillon. A tortillon, or stump (*see* page 41), is a tight roll of paper. You can easily make your own.

Right: *To make a tortillon, begin by cutting a piece of light paper, such as drawing or typing paper, into a tall triangle or a triangle with its top cut off. Turn over the bottom edge and roll up the paper as tightly as possible. Seal the loose end with a touch of glue or a piece of tape. Tortillons can also be made from paper towels, but you will need a stiffener—try rolling the paper around a toothpick.*

Using a tortillon

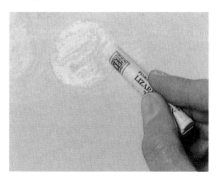

1 Choose the two shades that most closely match the overall color of the fruit, and apply them lightly

2 Begin building up the forms with darker colors, using the tortillon to blend the shadow areas only.

3 To avoid overblending, decide where subtle effects are most important. The edge of the shadow needs softening, so use the tortillon here, and also for the halo of reflected light at the bottom of each piece of fruit.

Is it OK to blend with my fingertips?

Always wear a latex, nitrile, or similar glove or a finger cot when blending with your fingers.

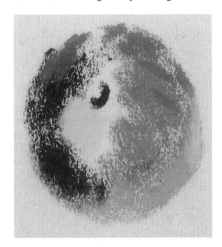

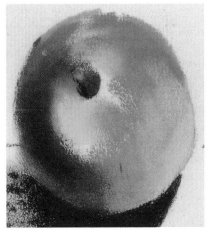

Above: *The blocks of color have been put in without outlining to build a solid form; the strong contrasts help to keep the drawing lively.*

Above: *The edges of the fruit have been blended with a fingertip and a dark shadow has been added to give weight and dimension to the fruit.*

What is broken color and why is it called That?

Broken color is a term used to describe an uneven layer of color that is laid on deliberately so that it only partially covers the surface and allows colors beneath to show through. A sky, for example, might be built up with short, light side strokes of various blues and violets laid over one another but left unblended, giving a much more vibrant color effect than flat, blended color.

The aim is to create a coherent but lively area of color that reads as one color when viewed from a distance. This method is sometimes called optical mixing because the colors mix in the eye.

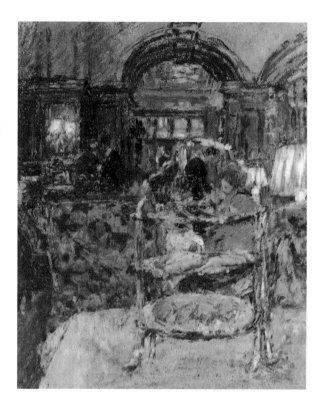

Above: Teatime, Brown's Hotel by Diana Armfield *In this interior view, the broken-color effects create a shimmering, atmospheric impression. The color combinations describe form, texture, and pattern, with grainy marks also allowing the tone of the paper to show through in places.*

What is scumbling technique and how does it modify colors?

scumbling technique ✗ *✗e*

Like feathering, scumbling is a method of modifying the color of a toned paper or layer of pastel by applying roughly circular strokes of another color over it.

Whereas feathering uses the point of the pastel, scumbling involves using the side of the stick in a loose motion to create a thin veil of color which doesn't entirely obliterate the one underneath. The two colors mix optically and have more resonance than an area of flat, blended color does. The effect is like looking at a color through a thin haze of smoke.

Scumbling not only creates subtle color effects, it also gives a very attractive surface texture. Use it to give depth and luminosity to your colors and to soften and unify areas of the painting.

To scumble, use the side of the pastel and make small, circular movements over the area to be covered. Apply only very light pressure, and don't overdo it or the underlay will be completely covered and the effect will be lost. Soft pastel, in particular, requires a very light touch. This technique works best on a paper with plenty of tooth, which won't become clogged too quickly.

Scumbling

1 Scumbling is suitable for large-scale pictures or for backgrounds, where you do not need to control shapes precisely. Scribble lightly over an area of paper, using the side of the pastel stick in a circular motion.

2 After blending the first color with your fingers, apply a paler layer of scribbled marks in open strokes that will enable the underlying color to show through.

3 Scumble a pale gray in gentle strokes over the first two colors. Scumbling generally works best with light over dark, but it can be useful for subduing an overly bright color.

Above: *Scumbling light over dark gives a pleasing shimmer, as the colors are broken up in an irregular way.*

Right: The Artist by John Elliot
This portrait has a fascinating ambiguity—the eye is immediately taken by the patriarchal white beard before registering that this is attached to a face not yet aged. In the beard and hair the basic colors are loosely laid in with a form of scumbling, then developed with a complex pattern of brief, vigorous linear marks. In the face, the hatched and shaded colors are more closely integrated, giving the firm profile sculptural quality.

I've heard the term lost and found edges. Can you tell me what that means?

This is the sharpness or softness of the transition between objects. Using both lost (soft) and found (sharp) edges within one painting creates depth and interest.

Left: Rain Dance by Barbara Benedetti Newton
The crisp strokes of the branches and grasses in the foreground are the starting point for the viewer's eye. Lost edges in the water, bushes, and tree tops move the focus backward to the darker line of trees and the hillside.

I've heard that a variety of strokes in a painting create interest. How can I use differing techniques in one painting and still have unity overall?

Unity of technique (or stroke) is also important. Do not use a flat blend in one area and positive line strokes in another. If you have done this, soften the line strokes with a little light blending, or apply some line strokes over the blended areas, to remove the disjointed effect.

Below: A Reason To Dance By Barbara Benedetti Newton *Another method of achieving unity within a painting is to repeat similar strokes of color in several areas in the painting. In this painting, the artist repeats the color and characteristics of the dancing blades of grass as sky peek-holes in the background.*

How do I make bold reflections and highlights?

bold ref

To make reflections, practice your strokes on another piece of paper first. Most often, the end of the pastel stick is used or even the sharpened tip of a hard pastel. Light values next to dark and complementary colors adjacent to each other create areas of color and value that draw the eye.

Below: Hot Tub No. 11 by Kitty Wallis *The interaction between confidently placed marks of color and the background where they are applied makes a sparkling statement in this colorful painting.*

Figure looks solid, but varied marks prevent a static look.

Linear marks and squiggles overlie more flatly applied color of underpainting to convey movement.

Deep blue of water reflects onto hands, producing an exciting color effect.

I've heard the term "working thin to thick;" what does this mean?

When working in oil, a common technique is to work thinly in the first application of color and then layer thicker paint on top. When using pastel, start with hard pastels to imitate the thin first layer without clogging up your pastel paper texture. Then, move on to soft pastel for the majority of the work, perhaps returning to hard pastels or pastel pencils for final detail marks.

Right: Sunfall by Barbara Benedetti Newton *Both hard and soft pastels were used for the final details.*

Can I mix pastel with other media?

Pastel is very versatile and can be used with almost any other medium, depending upon the effect desired. If pastel is the major medium and the last overall color applied, the painting can be labelled a "pastel painting."

ARTIST'S TIP

Use acrylic paint to block in the darkest and lightest values before applying pastel. When the acrylic is dry, use hard pastels in middle values to indicate where soft pastel colors will be placed.

I am familiar with charcoal for value studies. Can I use charcoal and pastel together in a painting?

Charcoal is the medium traditionally used for sketching the layout of a composition, providing the framework of guidelines for the later application of color and tone.

You can create a clearly defined charcoal sketch to begin with, then carefully brush away any flecks of the loose charcoal with a soft paintbrush before introducing the pastel color work.

Subduing colors

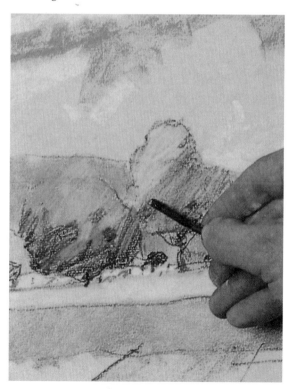

Left: *Charcoal is also useful for toning down any area that looks too light or bright. In landscape, for example, you often find that a color used for some feature in the middle distance may appear over-assertive. By laying charcoal on top and lightly blending the two, you can subdue the color, turning a bright green or blue into a grayed-down version of the same hue.*

There is a danger of charcoal dust spreading onto and sullying the pastel colors. It is best to begin with the charcoal, and when you add pastel color, keep the two areas separate—or fix the charcoal first.

If you use charcoal to lay in broad areas of tone, such as dark shadows, you will be applying pastel color on top; whether you fix the charcoal before doing this depends upon the effect you are seeking. If you want the colors to be muted, leave it unfixed, and deliberately allow the pastel color to mix into it. This can be an excellent method for any subject with a somber color key, such as a cityscape at dusk.

Below: *Charcoal is often used to sketch the layout, but it can also be mixed with pastels once you begin to add color.*

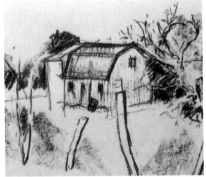

Charcoal line and tone

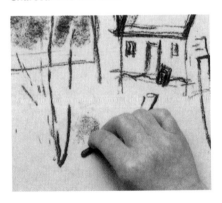

1 Make a full drawing, using a medium-thickness stick of willow charcoal. Use the point of the stick for the lines, and the side for areas of tone.

2 Do not restrict yourself to outlines, as you would with an underdrawing. In this method, the charcoal plays a definite part in the picture rather than being covered up with subsequent layers of color.

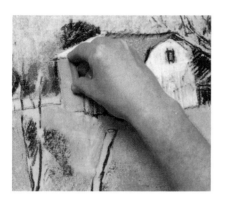

3 When the drawing is complete, begin to apply pastel color, blocking in the sky and foreground grass. For the bright hue of the house wall, you will need to mix colors, so use the side of a stick to drift blue over green.

4 Vary the sky colors by laying a little pale yellow over the blue, and use your fingers to blend them. Be careful not to smudge the house while you do this.

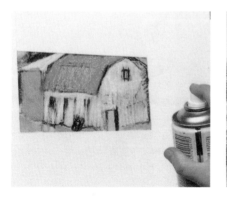

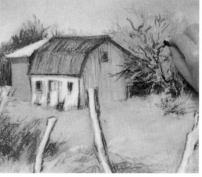

5 More color is needed on the house, but the charcoal and pastel mixture there is already thick, so fixing is advisable. Mask the rest of the work with paper and spray lightly.

6 With most of the colors now in place, use the charcoal again to draw into the trees and add detail to the roof and windows of the house. Continue alternating pastel and charcoal until you feel the picture is finished.

Are gouache and pastel compatible to use together?

Gouache and soft pastel are ideal partners for mixed-media work, providing similar color character and complementary textures. Both are opaque media in which the pure hues and tints are particularly bright. Gouache lightens slightly as it dries, and its paler colors are highly reflective. In combining these media, let the gouache do the painting and take advantage of pastel's qualities as a drawing medium to provide additional detail and textural contrast. Exploit linear strokes and massing techniques that can be integrated with flat washes of gouache, broad brushmarks, or heavy impasto.

This is an excellent combination of media for outdoor subjects—landscape and townscape. You can block in the general color areas with gouache and work over them with pastel to develop the textures and patterns of, for instance, grass, flowers and foliage, or building materials and architectural details. Another good use of pastel in this context is for inserting figures after you have established the main features of your outdoor scene, freely drawn over the dried gouache, and for touching in final highlights and color accents.

Gouache and pastel

1 The composition is lightly sketched in with a pale yellow soft pastel. Initially, washes of gouache color are laid into the background area, blocking in the main forms of the building.

2 Basic shapes and colors in the market stalls and roadway are similarly blocked in. In these early stages, the main purpose is to eliminate most of the white paper and create a colorful surface for working over in more detail.

3 The ribbed pattern of the stonework on the left-hand wall is drawn over the dried gouache layer using brown and orange soft pastels. Thicker bands of gouache are overpainted on the same area.

4 The combination of media is freely worked to develop texture and color overall. With the figures blocked in, all the white paper is now covered, and pastels are used to draw in finer detail on the figures and stalls.

5 Pastel work on and around the figures is quite free and sketchy, but designed to model the forms more solidly and give an impression of greater detail. The grain of the paper is still visible, although the pastel is applied over opaque gouache.

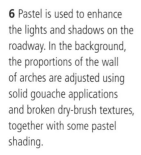

6 Pastel is used to enhance the lights and shadows on the roadway. In the background, the proportions of the wall of arches are adjusted using solid gouache applications and broken dry-brush textures, together with some pastel shading.

I like painting in oil but I would like to try pastel. Can I add pastel to an oil underpainting?

A thin oil wash can produce large areas of subtle color and interesting effects that can stand alone in a pastel painting.

Below: My Blue Heaven by Barbara Benedetti Newton *In this abstracted landscape painting the warm oil-wash foreground was left to stand alone as blue pastel is added to create the trees in the distance.*

Can I start with a colored ground, add an oil wash underpainting, and then use pastel as the last layer?

In this painting, an overall pink oil wash was applied to a homemade pumice surface to create a pink ground. Pink paper could also have been used.

Right: Hometown Marshland by Barbara Benedetti Newton
Indications of the scene were painted in white oil and few darker hues.

Right: *To complete the painting, pastel was applied sparingly, leaving much of the pink surface and the oil underpainting to stand alone.*

What about using graphite pencil and pastel together?

However dextrous you become in manipulating pastels as drawing tools, it is difficult to sustain a hard, sharp line in this medium.

Some subjects suggest a style of rendering in which linear qualities should be combined with a softer technique—seaspray washing over jagged rocks, for instance, or a bird of prey with a sharp beak and glittering eyes mounted on a mass of rumpled feathers. In such cases, pencils can be a useful complement to pastels.

Choose relatively soft pencils, those graded from B to 6B. In comparison with pastels, of course, even these are fine, hard drawing points, yet they produce a subtle variability of line and appreciably grainy texture that complement pastel qualities. If you are using the pencil only for line work, you can work it into and over pastel color, and vice versa. If you build up dense pencil shading or hatching, the slightly greasy texture of the graphite will resist an overlay of dry pastel particles.

Pastel and pencil

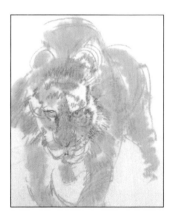

1 The basic form of the animal is blocked in with soft pastel, using linear marks and broad color areas rubbed with the fingers.

2 A furry texture is built up around the tiger's face with lightweight, feathered strokes of a 2B pencil.

Use the pencil decisively but delicately. If you allow the point to groove the paper and then try to erase any lines, the impressions will show up through pastel worked over the same area; otherwise, you can combine the media very freely. You could explore the combination of line and color further by trying other point media, such as colored pencils, felt-tip pens, and even pen and ink.

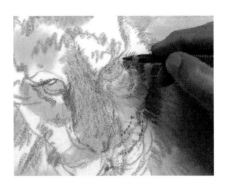

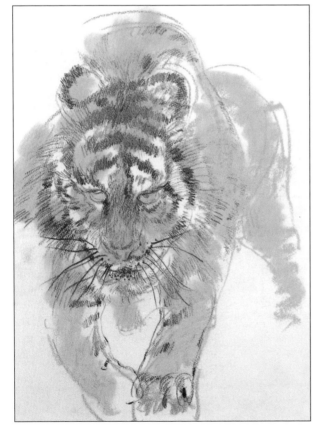

3 Pencil line is also used to sharpen the detail around the eyes and nose, working freely over the pastel color.

4 As the drawing develops, loose hatching and shading with the pencil builds up the stronger blacks of the tiger's stripes. Variations in the density of the pencil marks create texture and tonal variation.

I'm familiar with watercolor and acrylic. Can I use those media with pastel?

You can use either watercolor or acrylic, and in either case you must use paper that will not buckle when wet.

An underpainting can be as simple or as complex as you like. In a landscape it could consist of only two broad areas, blue or gray for sky and browns and greens for land. But you could take the process much further and fully establish the tonal structure as well as sketching in the important shapes, such as upright trees or rocks.

You can also achieve intriguing effects by using contrasting colors for the underpainting. Some artists choose a warm yellow underpainting for an area that is to be cool blue-gray, or lay a deep blue base over an area that is to be red. The ground color showing through the pastel strokes produces an exciting, vibrant effect.

Making an acrylic or watercolor underpainting

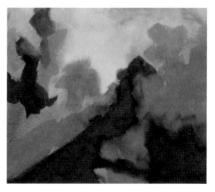

1 If the subject is colorful, it makes sense to give it a ground of bright color. Working on watercolor paper, use a broad brush to apply strong washes of watercolor (or acrylic).

2 Cover the entire surface with paint, applying darker colors where you want to build up dark tones of pastel. The deep purple here will be allowed to show through the lighter pastel colors for shadows.

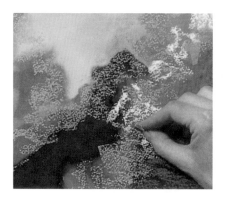

3 Allow the underpainting to dry thoroughly before working with pastel. Then use short side strokes in various colors to create broken-color effects, suggesting flowers and foliage.

4 Continue to build up the picture with small strokes. Do not try to cover the underpainting; the essence of this method is to leave parts of the watercolor showing between and beneath the pastel marks.

5 Now use the tip of the pastel to begin refining shapes and introducing small contrasts of color. Notice how the orange underpainting shows through the blue of the sky to give the painting a lively sparkle.

6 Flecks of yellow and orange underpainting enliven the areas of green and enhance the vibrant color effects. The heavy grain of the paper helps by breaking up the pastel strokes to suggest texture—especially evident on the path.

What is an example of a famous painting of pastel over gouache?

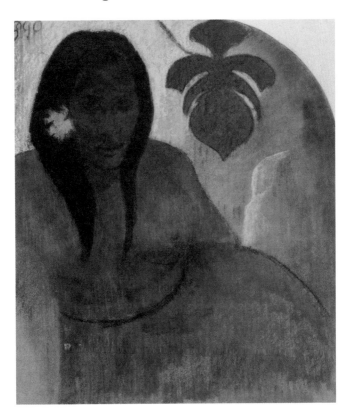

Above: Tahitian Woman by Paul Gauguin,1848–1903, Brooklyn Museum, New York *Soft pastel on paper with gouache underlay. Gauguin used pastel rarely, but here, working on a gouache underlayer, he was able to achieve a similar effect to oil paint using the clear, exotic colors which he loved, and using the edge of the pastel to outline the figure. The heavy, opaque yellow behind the blue-black hair serves to intensify the gaze of the girl. This is a good example of how changing the density of the pastel, coupled with sharp contrast in skin tone, can provide a focus of interest in the composition.*

What is frottage?

Frottage is a means of reproducing the effect of a specific texture by placing your paper over a textured surface and rubbing the pastel stick over the paper. The different features of the underlying texture show up as variations in the pastel color. Whether the surface is raised or recessed at any given point will cause the pressure of the pastel stick to vary and you will automatically obtain corresponding changes of tone from dark to light.

The character of your rubbing will also depend upon the type of pastel you use. Soft pastels and oil pastels will tend to form a cohesive surface effect, while hard pastels and pastel pencils show stroke marks that may be difficult to eliminate, adding a faint linear bias to the texture picked up from the underlying material.

Left: *Layered colors. Broken-color effects and complex textures can be built up with successive layers of frottaging. This works particularly well with regular textures like a mesh weave or evenly embossed surface. The interwoven effect of this sample is achieved by moving the paper slightly between colors so each application mixes with the one before.*

Left: *Corrugated cardboard. Unusual textures can be particularly effective if suitably matched to a given subject. For example, the ribbed texture of corrugated cardboard could enhance the effect of a landscape or townscape view.*

How can I make delicate random color or texture?

When you want a dusting of detail color, try sprinkling pastel.

To sprinkle pastel, place your painting on a flat surface in front of you. With the desired pastel color stick in one hand and a craft knife in the other, lightly swipe the blade of the knife down the side of the pastel. Particles of color will fall

Below: River's Edge by Barbara Benedetti Newton *In this autumn scene, the edge of a rectangular pastel was used to make tree trunks and leafless limbs.*

Above: *Sprinkling pastels is an easy and effective way to add colorful detail.*

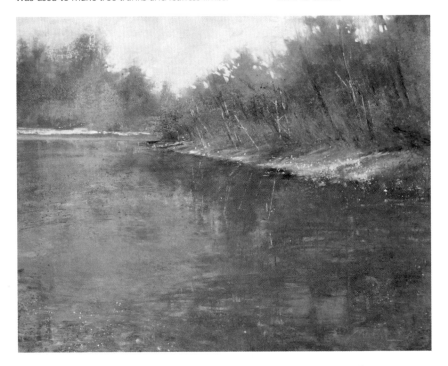

onto your painting. Experiment with the distance from the paper, pressure of the knife, and hard and soft pastels to get the effect you want. Next, lay a piece of glassine over the sprinkled area and press firmly with your hand to "set" the particles in place on the painting.

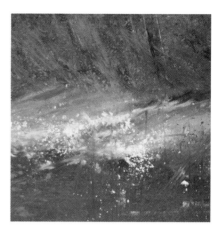

Right: *Light color pastel suggests riverbank rocks. A darker value and different color was used for underwater rocks and foliage.*

What is linear texture and how do I make it with pastel?

Scraping out can be used as a positive element of drawing technique for introducing very fine linear texture in a color composition.

Right: *In this example of linear texture, the tip of a blade has been used to draw into heavily applied color, creating the whiskery effect of the seedheads and enhancing the complexity of the varied directional lines in the massed grasses*

How do I incorporate ground texture into my painting?

An atmospheric painting with little detail is a good candidate for the use of a boldly textured ground.

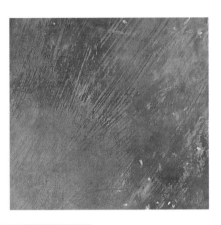

Below: Summer Evening by Barbara Benedetti Newton *Here the artist applied gesso with a paintbrush to her painting surface before any color was added. The strokes of the brush make ridges of gesso that then catch the pastel color.*

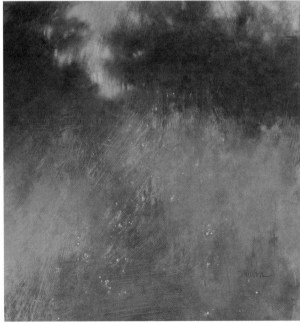

Above: *This detail shows that the gesso pattern helps to portray the dry grasses of summer.*

What is stippling with pastel?

Stippling is the technique of using dot patterns to build an impression of shape and form. It is particularly associated with monochrome drawing, a way of shaping forms through tonal gradations of light and shade. The resulting image contains no lines.

The size and spacing of the dots in stippling is varied so that different areas of the dot pattern convey different tonal densities when viewed from a distance. In color work, stippling can be used to enliven areas of massed color, using either individual or closely related hues, or mixed colors applied directly to the support or over a light layer of pastel color already laid in.

If you stipple with soft pastels or oil pastels, you are likely to achieve quite a coarse, irregular stippling. Even if you sharpen the end of the pastel to begin with, it immediately wears down in use. With hard pastels or pastel pencils, you can obtain a finer, more controlled effect because these media do not spread so rapidly. Pencils can be sharpened frequently to maintain a true point, and the corner of a square-sectioned hard pastel will also give you quite a precise, confined mark.

Right: *Pastel pencil. The harder, fine tips of pastel pencils provide the means for very fine stippling, but this means that covering a large area of the paper may be very time-consuming.*

Right: *Soft pastel. Depending on the pressure you apply to the pastel tip, the effect of stippling in soft pastel can range from fine to very coarse. Integrating dots of different colors enables you to build up an increasingly detailed image, with graded hues and tones modeling individual aspects of the form.*

What is *sfumato*?

The characteristic of the effect called *sfumato* (an Italian word meaning smoke-like) is a soft, hazy quality in which tones and colors merge into each other and build an image without reliance on linear structure or emphasis on edges and contours.

Sfumato is not a technique in itself, but a visual quality, and you can achieve the effect by using any of the techniques that enable you to apply controlled, subtle color transitions: blending, color gradation, scumbling, and shading. If your image has a varied range of tones and a shadowy or atmospheric mood, you can also use careful erasure to lift light out of dark and develop gentle contrasts of light and shade.

Above: *To create this picture, the subject was first blocked in with blue and gray soft pastels on a buff colored paper, using sketchy outlines and loose hatching to define the areas of light and shade. The pastel strokes were softened and spread with a tortillon to make the marks less linear and allow the colors to merge. Then the color areas were gradually built up in lightly shaded layers. Dark tones were smudged with thumb and fingers to create patches of soft shadow. The form of the cat's head was developed with dark and light tones. The colors were freely applied using the tip and side of the pastel sticks and blended using fingers or a tortillon as appropriate. In the final stages, the features were drawn with feathery pastel strokes, some blended into the previous color and others remaining more clearly defined. Although there are no hard edges or distinct outlines, the dramatic use of light and shade makes a highly descriptive impression of form and contour.*

What does impasto mean?

In some pastel paintings you can see that the color is so thickly applied that it almost resembles oil paint—this is called impasto. Such works are produced by a variety of overlaying methods—they sometimes involve wet brushing and often call for the use of fixative at various stages.

Impasto effects

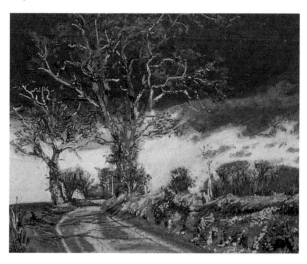

Above: Between Showers by Margaret Glass *Impasto means applying paint so thickly that you can see raised edges. In pastel work, you can achieve an equivalent result by using the full strength and texture of the pigment in heavy strokes. Mounting sandpaper on a rigid surface enabled this artist to apply maximum pressure.*

Above: *The detail here shows that, on the branches, the effect is close to that of oil painting.*

CHAPTER

4

COLOR
AND VALUE

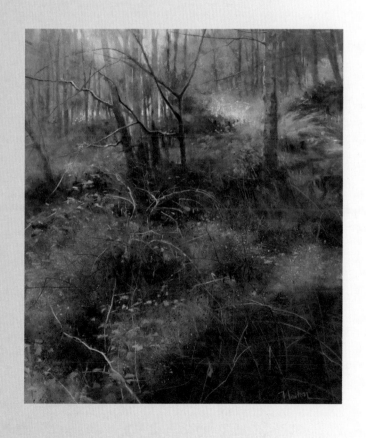

There are so many color terms it is confusing. Can you explain them in a simple manner? What is meant by hue?

Hue describes the color family such as red, blue, etc.

What is color intensity?

Also called chroma, this is the brightness or dullness—the saturation—of a color.

What are the primary colors and why are they called that?

Red, yellow, and blue are known as the three primary colors because they are the only colors that stand alone. Mixing other colors does not create them. The three primary colors are also typically referred to as magenta (red), cyan (blue), and yellow, when described in the printing process. Theoretically, it is possible to mix every other color from the three primaries.

What are secondary colors and how would I make those colors?

When any two primary colors are mixed together, they form a secondary color. For example, blue + yellow = green, red + yellow = orange, red + blue = violet.

What are tertiary colors?

Tertiary colors are made by mixing a primary and secondary color. For example, red + orange = red-orange; yellow + green = yellow-green; blue + violet = blue-violet.

> **ARTIST'S TIP**
> To imitate the three primaries in art, use Prussian blue as blue (cyan), madder for red (magenta), and lemon yellow for yellow.

What is meant by value or tone and why is it important?

Value (tone) is the lightness or darkness of any color. All paintings should have a range of values. If the range is too narrow, the viewer's eye slides quickly over the scene and interest is lost. A good way to check the value range of your painting is to photograph it and turn it into a grayscale version.

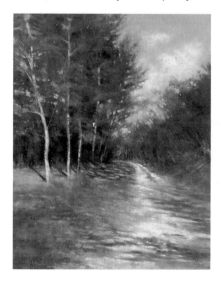 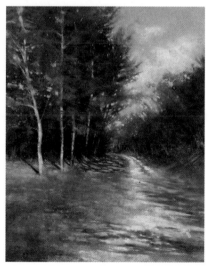

Above and above right: September Sideroad by Barbara Benedetti Newton
A wide range of color values will hold the viewer's attention.

What is the color wheel and why do I need to know about it?

Once you begin to paint seriously, you will also need to understand some of the characteristics of colors, and discover how they behave when placed in different relationships to one another.

Color is one of the painter's most potent means of expression, and you can use it to emphasize the mood of your painting, thus creating an emotional response in the mind of the viewer.

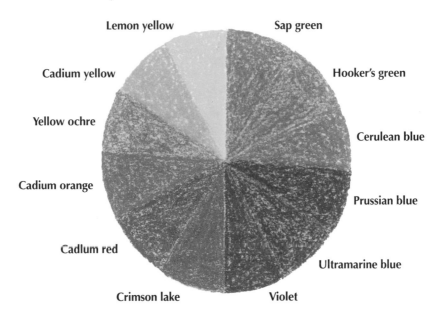

Above: *The color wheel is a theoretical device that can be referred to when experimenting with colors and the ways in which they react with each other. It is really just a simplifed version of the spectrum, bent into a circle. In the color wheel above, for example, you can see how those colors that are next to each other tend to harmonize, while colors on opposite sides of the wheel, called complementary colors, are sharply contrasting. The complementary relationships continue around the color wheel in respect to the secondary colors too so that, for example, yellow-green is complementary to red-purple, and blue-purple to yellow-orange.*

What are complementary colors?

Any two colors diagonally opposite each other on the color wheel are called complementaries. For example, blue is the complementary of orange, red of green, and yellow of violet. The complementary of a secondary color such as red-orange is blue-green, and so on. Complementary colors need to be carefully controlled in order to be successful in a painting, but when used wisely they have great dramatic impact.

If two complementary colors of the same tone are placed near each other, they intensify each other by color contrast. Though you're not physically aware of it, the eye jumps rapidly from one color to the other, causing an optical vibration that makes the colors appear to shimmer.

If complementary colors are used in large amounts and in equal proportions, however, the effect will be garish. The secret is to create a web of small flecks of broken color, as the Impressionists did, so that the overall effect is harmonious.

You can also use a small patch of a complementary color to counterbalance a large area of a particular color (notice how vibrant red poppies appear when growing in a green field, for example). Yet another method is to tone down both colors with their complementaries; for example, if you're painting a bowl of red apples against a green background, introduce flecks of green into the apples and flecks of red into the background—the colors will still intensify each other by their prescence, but the overall effect will be more subdued.

What are color schemes and why are they important in the planning process?

When planning a painting, you will have certain colors in mind. To make your painting colors harmonious, using colors with known compatible relationships will help.

A monochromatic color scheme is when colors have one base hue and are varied by the addition of white to make a tint that is lighter, or black to make a darker shade of the base color. Pastel sets usually have many tints and shades of a color such as blue, red, etc.

Analogous color schemes have hues that are adjacent to each other on the color wheel.

Complementary color schemes consist of two colors directly across from one another on the color wheel.

A split complementary scheme involves finding complements on the color wheel such as yellow and purple, then using one of the two complementary colors, with the two colors on either side of its complement for a total of three colors.

Triadic color schemes use three colors equidistant from each other around the color wheel.

When I think of neutral, I think of the color gray. What is meant by neutral colors?

The neutral colors—the grays and beiges that are often hard to give a name to—are also a powerful ally in setting up contrasts, as their presence in a painting helps to make brighter colors sparkle. But you have to choose these colors carefully, because none of them are fundamentally neutral. They all have a slight color bias—a gray can be greenish, bluish, or have a violet tone. You could bring in a touch of complementary contrast by setting bright red against a greenish-gray, yellow against violet-gray, or green against reddish-brown.

Neutral colors

Raw umber

Blue-gray

Warm gray

Green-gray

Purple-gray

Shown left are just a few examples from the large range of so-called neutral colors produced by pastel manufacturers. However, they all have a definite color bias and must be used with care, because they might look bright in a painting that has a muted color scheme.

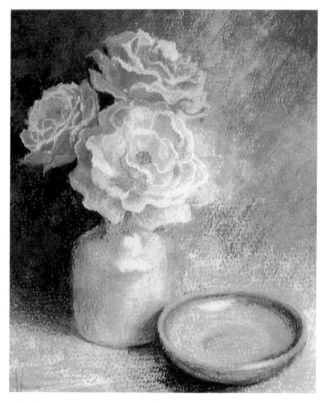

Above: Pink Roses by Maureen Jordan *Most of the colors in this delicate painting can be described as neutral, but because the most vivid ones—those of the roses—are not strong in terms of either hue or tone, the grays, green-grays, and rich browns are perceived as having more color than they might in another setting.*

Is it possible to neutralize a color?

When complementary colors are used next to each other, they intensify each other. Conversely, if they are mixed together they cancel each other out and form neutral grays and browns.

Neutralizing with complementaries
Violet and yellow mixed together form gray, and red and green make brown. Depending on which colors are used and the proportions of each, you can create a wide range of colorful neutrals—blue-grays, brown-grays, red-browns, gray-browns, and so on. Mixing all three primary colors together also produces a neutral gray. In the case of pastels, mixing will, of course, take the form of blending or scumbling, but the theory applies equally to pastels and paints.

Neutral colors don't have to be uninteresting. They should be subtle, but still lively; they are a necessary foil to more brilliant colors. The beauty of pastels is that since they cannot be pre-mixed, as paints are, you will achieve such effects without really trying.

What is color balance in a painting?

A balance of colors is important to keep the sparkle and tension in a composition. Remember that red and green are complementary colors, as are yellow and violet, and blue and orange. Adding a complementary color immediately enlivens a composition. When you add fresh colors you can use a soft pressure and allow the one underneath to show through in some areas, which will give an additional richness and a painterly quality to the work.

Right: October by Barbara Benedetti Newton *Complementary colors, when placed side by side, intensify each other.*

Can you give me a simple explanation of what color temperature means?

If you look at the color wheel, you will see that the red/orange/yellow half appears "warm," whereas the violet/blue/green half appears "cool." The reasons for this are partly scientific and partly psychological; we associate reds, oranges, and yellows with the sun and firelight, and blues and greens with the coolness of grass, foliage, and water. In addition, warm colors tend to come forward visually, whereas cool colors appear to recede when placed near warm colors.

Within these broad categories, we find that each color group itself has varying degrees of warmth or coolness. Thus, in the red group, cadmium red is warmer than alizarin crimson, which contains a percentage of cooling blue. Similarly, yellow ochre is a relatively warm yellow because it contains some red, whereas lemon yellow veers toward green and appears cooler.

Although the theory and its terminology needs to be understood, the really interesting part is learning how to apply it to the actual paintings.

Warm and cool primaries

Warm **Cool**

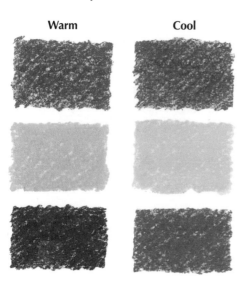

Left: *Although red and yellow are described as warm, and blue as cool, there are variations in temperature within each hue. Here the three primary colors are shown with the warmer version on the left and the cooler one on the right.*

Is the temperature of one color influenced by other colors in a painting?

The temperature of a color is also influenced by neighboring colors. Pastels will look warmer, cooler, brighter, or more muted according to adjacent hues. If you put a bright red or orange against a gray background, for example, it will have more impact than it would if it were placed on yellow or another red.

Sometimes a color will have too much impact. For example, a blue chosen for the distant hills in a landscape will not recede properly, even though it is a cool color, unless the foreground colors are more vivid and substantially warmer.

Bear the idea of these color relationships in mind as you work, and you will quickly learn how to play off one color against another and set up the kind of exciting contrasts that make painting such a rewarding activity.

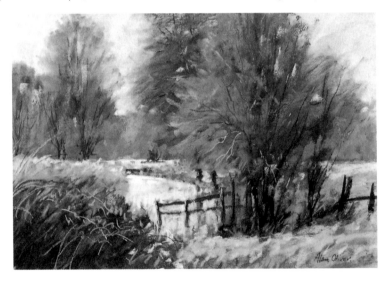

Above: Frosty Morning by Alan Oliver *The blues used for the distance push the background away, giving a strong sense of space. The artist has chosen a relatively warm blue, but it is still much cooler than the russets and red-browns adopted for the central group of trees and the foliage in the immediate foreground.*

How do warm and cool colors work in a painting?

The concept of warm and cool colors plays a vital role in painting. The cool colors, which are the blues and any color with a blue content (blue-green, blue-gray, etc.) have a tendency to recede—that is, they appear to draw themselves toward the back of the picture. The warm colors, which are the reds, oranges, and orange-yellows, do the opposite. They are the "pushy" colors, advancing to the front of the image.

These properties of colors help you to create the illusion of three-dimensional space in a painting. If you use cool colors in the background—for distant hills in a landscape—and warm ones for the foreground, your painting will have depth.

Advance and recede
However, it is not a matter of choosing any blue, because all colors have warm and cool versions. Some blues are purplish, veering very slightly toward red, and are therefore warmer than those with a greenish tinge, such as turquoise. The crimson reds have a blue bias, and are thus cooler than the orangey reds, such as cadmium red. A yellow that inclines toward orange—cadmium yellow is an example—is warmer than the acid lemon yellows. This may sound complicated, but you will quickly learn to distinguish relative color "temperatures."

What are color contrasts and what are the dangers of using too many in one painting?

Color contrasts need to be handled with care: too much or too many can destroy the unity you have worked to establish. They are useful, however, when there is a predominant color in your painting, such as green in a landscape.

Landscape artists often use tiny touches of red or yellow—perhaps to delineate

flowers in a field or a few brightly clad figures in the middle distance of a scene—to enliven large areas of green. Flower painters sometimes deliberately restrict their color range, choosing mainly blue or white flowers, but including one small yellow or red bloom for contrast.

What is simultaneous contrast?

When two colors are placed side by side,
they interact with one another and the
effect is called simultaneous contrast.

Interaction of colors

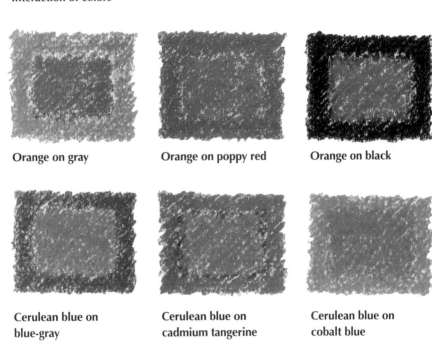

Orange on gray **Orange on poppy red** **Orange on black**

Cerulean blue on **Cerulean blue on** **Cerulean blue on**
blue-gray **cadmium tangerine** **cobalt blue**

Above: *These samples show how colors are affected by the
colors around them. Colors stand out well against neutrals
or black, but appear less vivid with placed next to a similar
hue. Complementary colors seem to vibrate when used next
to one another.*

I hear a lot about value and I think black, white, and gray, but what is meant by the value of colors?

All paintings should have some contrast between light and dark, because without it they look flat and uninteresting.

It is important to analyze your subject in terms of light and dark. This is not as easy as it sounds, because our eyes register color before tone. It is helpful to half-close your eyes, which dulls the color and blots out detail. Try this, looking out of a window. You may see that a tree whose leaves you know to be a pale green is in fact darker than a wall behind it, and almost certainly darker than the sky.

Tone has an equally essential role to play in modeling form. An apple looks round and solid because the light that falls on it produces highlights and a gradation from medium to dark tones. You will not be able to make it look solid unless you can identify the tones and the colors involved.

Judging color value

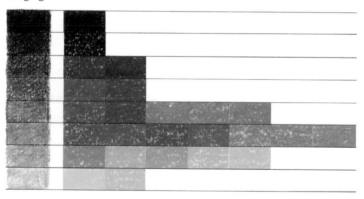

Above: *If you are using the recommended starter palette, become familiar with the value of all the colors by making a chart like this one. Prepare a "gray scale" with seven shades of gray, then draw up a grid and place a swatch of each color where it seems to fit in terms of value. This will help you to assess the values in your subject.*

How can I check to see if my painting has a good tonal/value range?

If you have difficulty judging the relative tones, try the old trick of half-closing your eyes (squinting) so that you see mainly dark and light tones. This cuts out most of the color and extraneous detail, reducing the scene to shapes of light and dark. As a general rule there should be a dark, medium, and light tone, all providing contrast in an interesting pattern.

There may be times when you plan a work with very slight tonal contrast, as in a very delicate drawing, but generally speaking, the tonal structure of the painting is like a skeleton in a body—it gives it shape and form and holds it together. The larger the work, the more important this is. If you are having trouble with the tones you might want to try a work using just black and white or dark brown and white. If the problem is a tonal one it is very easy to correct this by overlaying darker tones of the same colors where necessary and accentuating the highlights.

The best way to judge the tones of your subject is to look for a neutral middle tone—say, the gray of a sky or the soft green backdrop in a still life—and compare the rest of the tones to this to see if they appear darker or lighter. Keep your eyes moving all the time, from one tone to another and back again.

Can you give me an example of excellent tonal composition?

Opposite: Mery Laurent In A Large Hat by Edouard Manet, 1832–83, Musée des Beaux Arts, Dijon, France *Manet fully exploited the velvety qualities of pastel in complete portraits. Here he has used cardboard, which he favored as a working surface, frequently allowing the color to show through. The painterly quality is the result of his practice of using a stump or his* hand to rub in large quantities of pastel. *Although it appears that he has used black in this study, he was in fact a master of very dark tones of rich color—the hat is actually the deepest possible brown and the dress a lustrous indigo. The work is a fine example of a strong tonal composition, with the white face framed dramatically to emphasize its delicacy.*

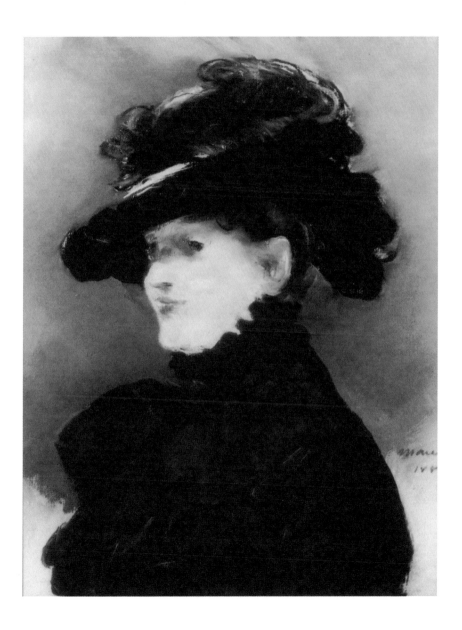

What is color perspective?

In reality, everything around us is three dimensional; in drawing and painting, however, we work on a two-dimensional surface. We have to observe and represent objects as if they were flat, like our paper or canvas.

Color perspective, also known as aerial perspective, which refers to changes caused by distance and atmospheric conditions, doesn't seem to have been grasped by artists until the late Middle Ages, when we first see an attempt at indicating distance by employing blue tones in the far background of paintings. Even then, the blue used by the artist was the same all over a small section of the picture, with every fine detail carefully drawn and painted. All around this small segment of bluish scenery, the painting was always equally strong in color, without any gradual diminishing of values toward the far background to give the illusion of distance.

How is color perspective used to create a three-dimensional illusion on a flat surface?

The biggest role of color perspective is generally in landscape painting, because greater distances and spatial problems are encountered in these subjects than in figure painting. Nonetheless, even in figures and portraits, the background is important, whether it is a plain backdrop of color, such as a wall or curtain, or a more definite and complex background, such as the interior of a room, a garden, or the kind of romantic scenery Leonardo da Vinci painted behind the Mona Lisa. A background, whatever its nature, must look like something behind the figure—not as if the figure were pasted on a sheet of cardboard or, worse yet, as if the figure were merely looking through a hole in a wall or in a curtain.

Opposite: Queen Anne's Lace by Barbara Benedetti Newton *The artist made use of perspective by narrowing the curving path as it recedes into darker colors and cool pinks. The warm yellows in the foreground offset the distant sky in cool lavenders.*

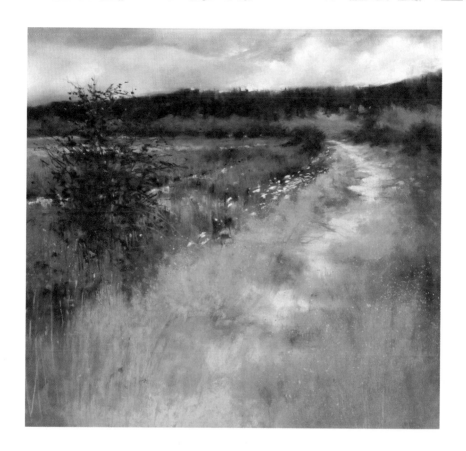

Why are value and temperature important in color perspective?

In color perspective, grasping and perceiving values is of the utmost significance. You may follow all the rules of linear perspective but still ruin your painting by neglecting important color values.

A shadow on a tree, on a house, on a road or on any object isn't merely darker than the rest; it's darker depending on the nearness or distance of the object. The brightest light on a green lawn that's seen at a distance is not as brilliant as on

Above: Where The Spotted Owl Flew by Doug Dawson *The artist has deliberately limited both his palette and his tonal range in order to convey the peaceful feeling of this woodland, but the colors used for the foreground area are darker and warmer than the greens, blues, and pale violets of the foliage beyond.*

the same kind of lawn near you. Not only are colors less bright in the distance, they are also more blueish in tone.

Compare the tones farthest away with the tones near you, and paint the shades between the two extremes proportionately. Applying the very darkest and the very lightest shades first is an excellent way to start your painting. Bear in mind that warm colors appear to advance, while cool colors recede. The more intense the warm color, the closer it comes to you; the less intense the cool color, the farther away it moves from you. Add a touch of red, orange or burnt sienna to any color, and it will come forward. Add a touch of white, blue, or green to any hue, and it will move backward. You have absolute control over colors.

Avoid jumping-out colors and holes

Colors in the distance painted as bright as the same hues nearer to you seem to be "jumping out of the picture" or look as if someone has pasted bright pieces of paper on it, perhaps mischievously. Even the casual onlooker feels that something is wrong with the picture.

Dark sections painted just as dark in the distance as similar objects in the

foreground appear to be holes or gashes in the picture. They're fine if you want to paint actual holes or gashes; however, if the dark hue is an accident, based on an oversight or a lack of understanding, then they are utterly wrong. Art students often paint tree trunks and shadows under the trees in the same colors and values in the farthest distance as those nearby. Such trees and shadows appear to be standing in one row across the picture, rather than in depth as the artist had planned. And even real holes in the distance must be lighter in value than similar holes nearby.

Although these facts are most noticeable and damaging in realistic subjects, they're just as disturbing in abstract or non-objective paintings. An artist working in any of these contemporary styles may wish to suggest a big hole, or something sticking out of the painting. Such color effects can then be utilized skilfully for aesthetic purposes.

Can I use color to unify a painting?

This subject might look unexciting seen from the front and under a gray sky. Here, however, with clever use of viewpoint and lighting, the sunlight brings the colors to life and creates a good shadow that, together with the three-quarter viewpoint, gives solidity to the structures.

Right: Forget-me-not, Buttercup by Rosalie Nadeau *The artist has unified the composition by using the same red-browns on foreground trees and roof.*

How can I use color and value to create a mood?

Some colors are warm and appear to advance, whereas others are cool and appear to recede. Using these properties of projection and recession, it follows that you can use warm and cool colors, respectively, to model form by emphasizing the projecting and receding planes of an object.

You can also create the illusion of three-dimensional depth and space, particularly in landscapes. Once again, nature is your tutor in the use of warm and cool colors; looking across a stretch of landscape, compare the cool, blue cast of trees in the distance with the warmer, more intense greens of those close to you. By capturing that color difference in a landscape painting, you will achieve a convincing sense of space and depth, because the eye perceives cool colors as being farther away than warm colors.

Warm and cool colors, because of their associations, can also be harnessed to help you express a particular mood. Warm colors suggest exuberance, optimism, passion, and cheerfulness. Cool colors, on the other hand, suggest calm, restraint, aloofness, loneliness, and sadness. Once again, these general rules shouldn't be taken as gospel; they are meant as starting points for your own ideas about color.

Tonal values

The ability to analyze the relative tones of a subject and match them in your painting is very important. Yet tone is a concept that gives many artists problems, amateurs and professionals alike. There is a much larger range of tones in life than in pastels. The tones around us range from 1–100, whereas those in paint range only from 1–40. Therefore, you have to make some tones equivalent in your painting. Just remember that tone doesn't refer to the color itself but to how light or dark it is in comparison to the surrounding colors. The tone of a color cannot be assessed in isolation because it has no existence except in the context of its juxtaposition with other tones.

Opposite: Edge Of Winter II by Barbara Benedetti Newton *This atmospheric painting makes dramatic use of tonal contrasts, or lights and darks, and the artist has emphasized the mood by using brighter details in the foreground.*

Can you show me an example of a painting that uses a limited palette of complementary colors?

Vincent's Chair With His Pipe, together with another piece he painted of the bedroom of the house, tells a story about his life at the time. Van Gogh frequently painted personal possessions in this way; for example, one still life shows a pile of books, and another a pair of battered boots.

Left: Vincent's Chair With His Pipe by Vincent van Gogh, 1888 *Van Gogh is not just painting a chair; he is painting his own chair in the house in Arles where he lived for a while, stamping his personality on it by including the pipe he smoked when relaxing.*

Another departure from the more usual still-life set-up is the choice of a high viewpoint; he is looking down on the chair from above, so that the seat is seen in its entirety and the chair fills the whole of the central area of the picture.

Above: Color and tone *Here, you can see the juxtaposition of one pair of complementary colors, blue and orange-yellow. These contrasts work best if the colors are kept close in tone, as they are here, with the blue mixed with white to equal the naturally lighter tone of the yellow. The color theme is repeated on the door, with a thin stripe of yellow painted over the blue wet into wet, so that the two colors have mixed slightly.*

Right: Structural emphasis *The bold blue outlines around the legs and struts of the chair give strength and solidity to the structure, as well as continuing the complementary color theme and separating the blue and yellow areas from the red and green areas of the floor.*

Above: Red/green contrasts *This passage of the painting brings in muted versions of the other pair of complementary colors, red and green, with mixtures made from these two colors. Notice how the richest area of red, behind the strut of the chair, is balanced by a slash of green, while the other tiles are painted with interweaving brushstrokes of greens, reds, and pinks.*

Can I mix any and all colors together or are there guidelines when mixing color?

One of the most appealing things about pastels is that the process of mixing colors takes place on the paper itself. Instead of colors being mixed beforehand and transferred to the paper, they develop as you work.

When you are working with a small selection of colors, you may have to mix them in a more dramatic way—combining two colors to make a third. To do this successfully, it helps to understand a few basic color facts.

There are three colors that cannot be made from mixtures of other colors. These are red, yellow, and blue, which are known as the primary colors. A mixture of any pair of these produces what is known as a secondary color. Blue and yellow make green; blue and red make violet; and yellow and red make orange.

A mixture of all three primary colors, or of one primary and one secondary color (three colors, in effect) makes what is called a tertiary color. Some of these tertiaries are the browns and grays, which are described as neutral but can be quite vivid. For example, if you mix two colors that are next to one another on a color wheel, such as blue (primary) and green (secondary), you will have blue-green, which is not a neutral color.

You should avoid mixing three primary colors together because the mixture may become muddy. It is best to restrict yourself to two-color mixes. An effective way of producing a neutral tertiary color is to use complementary colors—opposites on the color wheel. The three common pairs of complementaries are red and green, blue and orange, and yellow and violet—each pair consisting of one primary and one secondary color. They are so different, they neutralize one another.

Because pastel colors cannot be premixed as paints can, manufacturers produce a lot of secondary and tertiary colors. Even so, you will often have to modify existing colors. No pastel box, however extensive, contains enough greens to match the diversity of nature, so you may have to add yellow, blue, or even its complementary, red, to alter an existing green. And once you become familiar with your colors, you may discover that you can make a better green by mixing yellow and blue, or a subtle purplish-brown by combining red, blue, and yellow.

What will happen if I mix two complementary colors together?

Two complementary colors in equal proportions will make a neutral color.

Mixing complementary colors
Mixtures made by applying one color over its complementary, or opposite on the color wheel, are especially useful for shadows, which often lack sparkle. The mixtures here are half-and-half, but you can also use touches of a complementary color to gray a hue. If a green in the middle distance of a landscape looks too bright, for example, lay a very light veil of red over it.

Orange

Blue

Hooker's green

Red

Violet

Yellow

How do I slightly alter existing colors in my pastel painting?

Colors can be lightened, darkened, or modified in any number of ways by applying one over another. Yellow over green produces a pale but vivid yellow-green; green over cerulean blue creates a subtle blue-green; and the same green over ultramarine creates a stronger blue-green. Lemon yellow over burnt sienna makes a subtle orange; red mixed with burnt umber produces a rich color more interesting than the umber alone; and ultramarine blue deepens and enriches the green-gray.

Conduct some experiments of your own—it is the best way to learn about color mixing. You can lighten any color by laying white or a lighter tint of the same color on top of it, either blending it in or leaving it as is.

Black is effective for darkening blues, greens, and browns, but of little use for yellows and reds because it changes the nature of the colors. Black and yellow produces green, and black and red makes brown. To darken yellow, try mixing it with light brown. Red can be darkened either with deep brown or with purple.

Altering colors

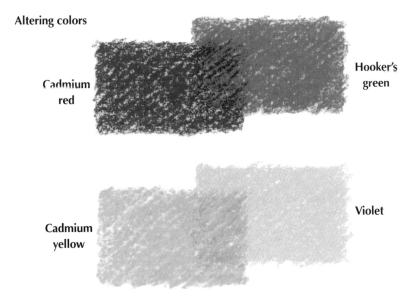

Cadmium
red

Hooker's
green

Cadmium
yellow

Violet

Hooker's green

French ultramarine

Cerulean blue

Hooker's green

Lemon yellow

Burnt umber

Burnt sienna

Cadmium red

Lemon yellow

Green-gray

Hooker's green

French ultramarine

What is optical mixing?

The same principles apply to pastels as to many painting media—for example, in the overlaying of colors to create new colors and transparencies.

In this picture, the artist has used thin strokes of pure color beside and on top of one another to give the impression of mixing colors and tones. The picture is based primarily on the use of warm and cool colors—red and blue—and their interaction with one another.

Overlaying pure color

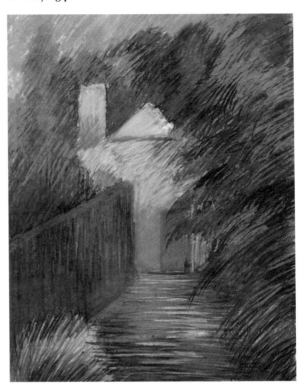

Above: *With pastel, the artist produces colors that mix optically on the surface by applying thin lines of pure color one over the other.*

Left: *Here, pale blue strokes are laid over crimson in the wall to create an impression of purple.*

How do I create depth by using color?

Objects appear more blurred and indistinct the farther away they are, and the tonal differences become much smaller. Thus, in a painting of a distant landscape, space and recession can be conveyed by softening the forms of trees or hills on the horizon and blending them into the color of the sky.

Above: Pigeons In The Campo Bandier e Moro by Diana Armfield
The lack of strong detail in the foreground area allows our eye to travel unhindered to the group of figures in the middle distance.

CHAPTER
5
GETTING READY
TO PAINT

Sometimes I get stuck and can't seem to get inspired to paint. Where do I find inspiration?

In addition to countless beautiful books available from libraries, we now have access to unlimited images by way of the Internet. Simply by doing a search in image mode related to a painting we may have in mind, we can view how many other artists have approached the same subject. Once you have identified a living artist whom you admire, you may be able to follow them via their blog or website or, of course, email them directly to ask for advice.

By studying the drawings and paintings of famous artists, we can recognize the wonderful impulsive style that marks the individual. In the 15th century Leonardo da Vinci was known to color his drawings with dry pigment, and throughout the centuries many great artists such as Renoir, Degas, and Picasso also used pastels. Although you will wish to develop your own style, learning some of the tricks from the Old Masters is sure to whet your appetite for pastel art.

What is Realism?

In art, Realism is the general attempt to depict subjects as they are considered to exist in reality. Realism was an artistic movement that began in France in the 1850s. Realists render everyday objects and scenes in a true-to-life manner.

What is Expressionism?

Expressionism was a modernistic movement originating in Germany at the beginning of the 20th century. Its typical trait is to present the world from an individual perspective, distorting one's perceptions of reality for emotional effect in order to evoke moods or inspire ideas.

What is Impressionism?

Impressionism is a 19th-century art movement that originated with a group of Paris-based artists. Freely brushed colors took precedence over lines and contours. The emphasis is on accurate depiction of light in its changing quality and ordinary subject matter shown in unusual visual angles.

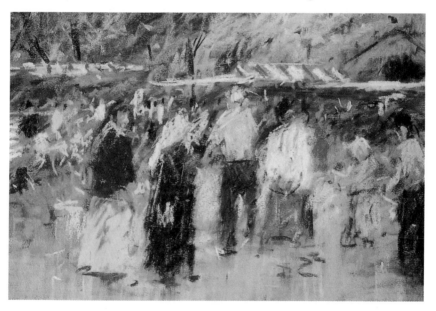

Varied, criss-crossing strokes suggest dappled light and echo the marks used for figures.

Short, jabbed strokes and scribbled marks hint at background figures and activity.

No detail on this figure, yet overall shape and posture are clearly conveyed.

Above: A French Market by Alan Oliver *By keeping detail to a minimum, the artist creates a powerful impression of market bustle. The figures are sketched rather than drawn, with rapidly applied side strokes from a short length of pastel. The feeling of movement is continued into the background.*

My style is to paint emotions expressed by color and shape. How would I describe my work?

Your painting would probably fall under the style termed abstract art if it has no recognizable references to the real world.

Abstraction indicates a departure from reality and stimulates the imagination and emotions of the viewer through shapes and colors. Soft, amorphous shapes and pale colors would convey a gentler message than angular forms in bold or bright colors. This is an art style where the temperature of color plays an important role in helping to communicate your message or story.

Relationships of shapes and forms will suggest movement and lead the viewer's focus around the entire painting. A thoughtful title will also help tell your story more clearly.

I'd like to add a color tint to white watercolor paper for a pastel painting. How do I do that?

If you like to work on watercolor paper, you will normally need to tint it in advance, because otherwise you will find distracting flecks of white appearing through your pastel strokes.

Laying an all-over tint
You can color the paper with watercolor or thinned acrylic, using a large, soft brush to lay an even wash of color. Or you can use ground-up pastel color to lay a "dry wash." To do this, peel some of the paper off one of your pastel sticks, or use a broken one. Hold the stick above a saucer and scrape it gently with a knife to make colored dust, which will fall into the waiting saucer. Then dip a rag or cotton ball into the powder and rub it across the paper, pushing it well into the grain.

What does "abstracting a scene" mean?

A painting that begins with a reference photo of a recognizable object may be interpreted in terms of color, value, and movement with just enough form to recognize the subject.

Below: Norham Castle, Sunrise by J. M. W. Turner, c. 1835–1840
In this painting, the artist was fascinated by atmospheric effects in landscape, and experimenting with ways of conveying these in terms of pure color.

I have papers and mounting boards I would like to use for pastel work. How do I make a textured ground to hold the pastel better on the surface?

The texture of the paper will influence the appearance of your pastel painting to some extent, but you can exploit texture in a more dramatic way by laying your own textured ground. To do this you need acrylic paint or a substance called acrylic gesso (a combination of chalk, pigment and plastic binder), along with a heavy watercolor paper or a piece of board, such as mounting board.

Put on the paint or gesso with a bristle artist's brush or ordinary paintbrush, aiming for a slightly uneven, striated look. When you lay pastel on top of this ground, you will find that the color catches on the small ridges, creating intriguing effects. It takes a little practice to discover how best the method can be used, but this is essentially an experimental try-and-see technique.

Acrylic gesso ground

1 Unless you want to work on a white surface, tint the gesso by mixing it with acrylic paint of a neutral color. This method is quick because there is only one layer to dry. However, you could apply the gesso first and then tint it.

2 Using a bristle brush, paint the colored gesso all over a piece of heavy watercolor paper. Aim for an uneven effect, because you want the striated texture of the brushstrokes to show through the pastel.

Personal experimentation

Below: Apples And Tea by Doug Dawson
Working on a homemade textured surface is essentially an experimental technique, and artists evolve their own recipes for grounds. This painting is on hardboard, which has been coated first with gesso, then with acrylic paint, and finally with transparent acrylic medium mixed with pumice powder. For the last coat, a paintbrush was used to make diagonal strokes, the effect of which can be seen clearly in the detail.

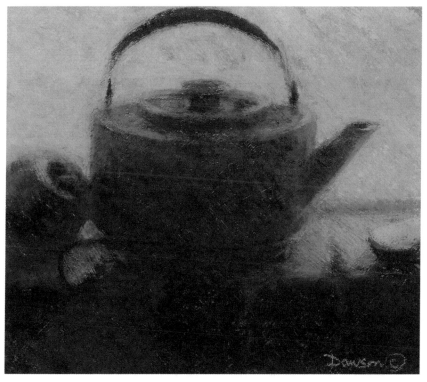

Before I start with pastel, I need some lines on my paper indicating the placement of objects in my painting. How do I do an underdrawing?

Because pastel is both a drawing and a painting medium, you do not always need to make a preliminary underdrawing. You can start off in color and draw as you work. However, for any subject involving a variety of shapes that need to be carefully related, such as a still life or figure painting, it is advisable to establish a good foundation.

Pastel pencils, hard pastel sticks, and charcoal are all suitable for preliminary work. Charcoal has an advantage over both pastel pencil and hard pastel, which are difficult to erase if the drawing goes wrong. You can brush down any incorrect charcoal lines with a rag or your fingers and draw over them. This way you can be confident of getting the shapes and composition exactly right before you lay on the color.

To avoid sullying the pastel colors, fix the charcoal drawing when you have finished it, or brush it down with a broad brush to remove the excess dust.

Pastel pencil

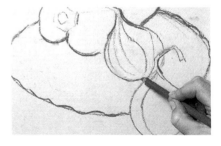

1 Pastel pencil is less forgiving than charcoal because it is less easy to erase, so do your best to be accurate from the start, and choose a color that will blend in satisfactorily with those of the subject.

2 Concentrate on outline, avoiding shading, and strengthen the lines only in places that will be dark in the painting, such as the bottoms of the fruit and plate here. If you make heavy lines in light-colored areas, you may not be able to cover them.

Charcoal

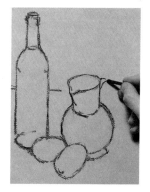

1 Medium-thickness willow charcoal is best for underdrawing; thinner sticks break easily. Hold the stick loosely near the top end and begin sketching the main lines of the underdrawing.

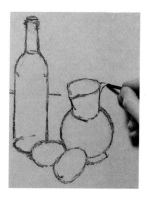

2 Errors can be erased quickly. Rub the charcoal off immediately with your finger before redrawing.

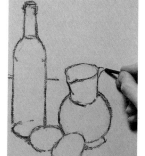

3 Correct the drawing, erasing again if necessary. The rubbed-down charcoal leaves a gray smear, but this will not affect the pastel color.

How do I apply an underpainting?

The process in applying an underpainting will depend upon the surface you are painting on as well as the medium used. A dry medium such as charcoal, pastel, or graphite or color pencil is applied directly but can be altered by rubbing with a rag or gloved finger or liquefied with a brush or spray bottle. When a wet medium is applied with brush, roller or rag, interesting effects can be achieved by spraying with the solvent for that medium.

What is meant by using an underpainting for pastel art?

An underpainting is a map to guide you to a successful pastel painting. You can use a dry or wet medium but if using paint, be sure your pastel ground can accept moisture without buckling or losing the integrity of the surface. One of the challenges for an artist is creating a good value range within a painting. If a tonal foundation is established before applying various colors, it can be used as a map to guide you in your pastel color choice. It has been said that value does the work and color gets the glory. An underpainting will help you have a clear vision of your story at the beginning to avoid an overworked painting.

When you have established an underpainting of differing values, follow it by by adding pastel color of the same value. The darkest underpainting areas will have applications of very dark pastels, the lightest areas or the paper that is left blank without an underpainting (sky, sunny highlights) indicate the lightest values. The remaining areas will be painted with mid-range colors of pastel.

Pastel ghost underpainting

Right: Luminesce by Barbara Benedetti Newton
In this example, the artist was dissatisfied with a pastel painting and brushed the pastel off leaving a "ghost" image of the painting.

Because the artist wanted to paint the same scene in the same colors, the ghost underpainting served as a color and placement map and aided her in creating a more confident new painting.

Black underpainting

Right: Where the Heart Is by Barbara Benedetti Newton *When composing a painting, begin with a line drawing, then mass the largest shapes with an underpainting. In this case, black paint was used. As the pastel painting evolved, darkest areas were enhanced by very dark pastel hues, the rest were adjusted into mid-range colors as shown by the tree's leafy branches.*

Value underpainting

Right: Sunday Walk by Barbara Benedetti Newton *Dilute your paint to create a three-value underpainting. This type of underpainting will show you which values of pastel colors to choose for each area. Mid-range colors of pastel were applied to the middle value underpainting in the road and on the grass. Lighter colors of pastel were applied where the underpainting indicated that they were needed.*

Can you tell me what the best medium is to use for an underpainting?

There is no "best" medium for an underpainting, only the one that best serves your purpose. You may choose a dry underpainting such as charcoal or a wet underpainting. If you decide on a wet underpainting, there are many options and the first question is what paper are you working on? Can your paper withstand water without losing the character of its texture and without buckling? The least side effects may be achieved by applying a pastel underpainting and liquefying the color with a brush and alcohol.

Opposite and below: Heartbreak Morning by Barbara Benedetti Newton *In this painting, a thin oil wash was applied onto tan sanded paper which had been previously mounted on a rigid surface with archival adhesive. Working quickly and spontaneously, the artist blocked in the major shapes and values. The oil wash dried in a few hours and was ready for pastel work.*

I've already started my painting in pastel, but I wish I had done an underpainting first. Can I liquefy the pastel now to use it as my underpainting?

Pastels are normally used dry, but they can be liquified with water or alcohol and spread with a brush.

Wet brushing is an excellent way of covering the paper quickly. By laying down broad side strokes and washing over them with a brush, you can produce a rapid underpainting. But this is not the only application of the technique. You can also use it as an integral part of the picture, so that brushstrokes of spread color complement the marks of the pastel. A bristle brush is best for this because it creates more distinct marks. Use alcohol instead of water for less chance of the paper buckling.

Wet brush underpainting

Right: Taos Fall by Bob Rohm *This work on sandpaper was built up in layers of rich color over a turpentine-brushed underpainting. The pastel color was dissolved with turpentine and scrubbed onto the paper. Here you can see marks made by the fluid color running down the paper.*

Using water

1 Thin paper may buckle when water is applied, so choose Mi-Teintes or watercolor paper. Block in the composition and establish the principal shapes and colors. Use light side strokes for this work.

2 Dip a broad bristle brush into clean water and begin to spread the pastel. Once wet, pastel takes on the consistency of paint and fills the grain of the paper with solid color.

3 Wash the brush to remove traces of the paler color, and spread black pastel on one side of the tree trunk only. This produces a gradation of tone that describes the form; specks of the paper still show through the areas of dry pastel, making it appear lighter.

One of the last things I think about when planning a painting is perspective. What do I need to know about perspective?

Whether your subject is one building or an urban panorama, you will have to come to grips with the basic rules of perspective. But these are not really alarming, and once you have mastered them you will find them helpful.

Things appear smaller the farther away they are. This is the starting point of all perspective. If you look at a table-top from the front, you will notice that the sides seem to angle inward, making the back shorter than the front. This is because all parallel lines receding from

you seem to converge, becoming closer together until they meet at a point known as the vanishing point.

The vanishing point is located on an imaginary line called the horizon, a word often used loosely to describe the division between land and sky or sea and sky, but in perspective it has a more precise meaning. The horizon line is your own eye level, so it changes according to where you are, becoming higher when you are standing and lower when you sit. It is important to understand this,

Plotting perspective lines

When making your preliminary drawing, sketch in the horizon line, then draw one of the receding horizontal lines—you could begin with a roofline or the tops of windows. Take this line down to the horizon (H) and mark where the two lines meet. This is your first vanishing point (VP). All the lines parallel with this will meet at the same place.

Single vanishing point

Here there is only one vanishing point for the buildings, because the viewpoint is the middle of the street. While the houses are built on level foundations, the road runs uphill, so the vanishing point is above the horizon.

because the horizon dictates the angle at which the converging parallel lines slope.

Your angle of viewing also affects the way the parallel lines behave, because the vanishing point is opposite you. If you stand in the middle of a train track, it will be directly in the center, but if you move to one side, it will move to a different point on the horizon line.

Similarly, if you look at a building from an angle, so that each side forms a separate plane, there will be two vanishing points—one for each plane. A complex grouping of buildings set at haphazard angles to one another will have many different vanishing points; but remember that each one is situated at your own eye level.

Two vanishing points

You can see two separate planes of this building, and each one has its own vanishing point, but at the same level—the horizon line.

Multiple vanishing points

For a subject like this, with buildings set at odd angles to one another, you cannot mark in each vanishing point. But do mark the horizon, and plot the perspective of the foreground buildings—like this.

How do I decide which format is best for the subject or scene I want to paint?

When you have a subject in mind that you would like to paint, whether it is a portrait, still life, or landscape, one of your first considerations should be choosing the right format.

Along with the compositional arrangement of the image itself, the size and shape of the paper or board should be considered carefully. With experience, you will come to think of your subject simultaneously with the shape and size of area it is to occupy. For instance, as a general rule, a long, narrow rectangle seems to be the right shape for the broad sweep of a landscape or seascape. A square shape suggests stability, and may be suited to a still life or a close-up study of a single object.

An upright format suggests strength and power, and is the usual choice for portraits. But does your view always have to conform to these rules? Would it be more effective to place a rectangle on end to make it vertical, and thus create a more arresting view of a seascape?

Size is also important. It can have a strong effect on the way a person works and, therefore, on the finished result. A large piece of paper may seem the right choice for a broad, atmospheric seascape, whereas a small one can be ideal for a still life or flower piece in bright, jewel-like colors. But although it can be enjoyable to experiment with different shapes and sizes, a good compromise for beginners is to work with a reasonably sized sheet and start the painting or drawing well within it. This allows room to expand and develop the painting outward in any direction, and avoids constraints imposed by the proportions of the paper.

Left: Passage by Barbara Benedetti Newton *The chosen format will have a great influence on the final painting, as the alternative vertical format shows here. Vertical formats are generally more active while horizontal formats are passive. When your subject is expansive as in this painting, a horizontal format works best.*

What is meant by the term "creating relationships" in a painting?

A general rule about composition is that there must be a relationship between the various parts of the picture. This relationship can be one of color, of shape, of technique, or of all three. As you work, always think about the painting as a whole, and try to set up a series of visual links. Landscapes, for example, are often less than successful because the two main areas—sky and land—are not "tied together" sufficiently. Try making a color link by taking a little of the blue you have used for the sky into the shadows and into areas of foliage.

Repeating colors is a sure-fire way of unifying your composition, and you can do the same thing with shapes. In landscape this calls for greater inventiveness, but you will sometimes note a similarity between, say, a cloud formation and a tree, and you can exaggerate the resemblance. In a still life, repeating shapes is easy, because you can set up your group with this in mind, choosing forms that share a natural relationship.

Left: Wear The Green Willow by Lionel Aggett *The repetitive shapes of the deckchairs form an interesting still-life group, sufficiently varied in their different heights and spacings to avoid a regimented effect. The color values and directions of the pastel strokes have been expertly controlled to create the subtle translucence exhibited by the deckchair fabrics.*

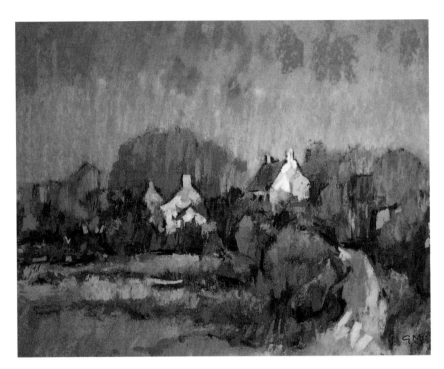

Above: Cottages At St. Jacques, Brittany by Geoff Marsters *Subtle use of the conventional device of a road draws our gaze toward the central group of houses, which forms the focal point. Color is also important to the composition; the eye is led by the bright patches of acid green repeated from the foreground trees to the foliage in front of the houses.*

Lead-in lines
The eye is led toward the focal point by the path, horizontal on left, curving treetops, and vertical marks used for sky and trees.

What is a focal point and why is it important?

Most pictures contain one main center of interest—a point to which the viewer's eye is inevitably drawn.

A picture that has a main center of interest will communicate more forcefully than one that does not. But what if your subject contains several objects or areas that are potential focal points? You must determine, first of all, what your picture is about, or what you want to say in it.

Right: Renaissance by Barbara Benedetti Newton *In this painting, the foreground leading to the tree has quiet color and little detail to draw the viewer's eye into the painting to the dark shadow beneath the tree, then the trunk, limbs and the explosion of color to the sky.*

How do I create the focal point or center of interest?

Emphasizing one element is partly a matter of subordinating the others, such as by keeping a background less detailed and distinct or in a lower color key. This does not mean that these subordinate areas can be poorly drawn, but rather that the drawing should be firmly understood but not stressed. In a still life, you may wish to place emphasis on a jug of bright flowers and play down the other elements; in a landscape, you can emphasize a dramatic sky by lowering the horizon line so that the land becomes less important by occupying less space in the composition; in a portrait, the sitter's face is generally the focus of attention, so you might deliberately tone down the colors and textures of the sitter's clothing, or treat them in broader and more sketchy terms.

What does balancing the elements of a painting mean?

The way in which a picture is divided up makes an immediate impact. It is, therefore, important to think of the picture in terms of abstract shapes, colors, and tones, regardless of what the subject matter is. Most pictures, for example, contain a focal point that is supported by other elements which lead the eye toward it, and these elements have to be carefully planned and placed. Think of your paper as a stage and yourself as stage director in charge of the actors, scenery, props, and lighting. Imagine you are directing a dramatic scene. How will you arrange the lighting and scenery to gain maximum impact? How will you position the principal character and the supporting cast?

What is symmetry and its role in a picture?

Symmetry is the quality of being made up of exactly similar parts facing each other or around an axis.

Wherever possible, avoid symmetry. If you are painting a landscape that features a large tree and you place it right in the middle of the paper, it will dominate the picture. The viewer's eye will go straight to it, ignoring other elements that you may have taken great pains over.

Such a picture will ultimately fail because it lacks a sense of movement. A painting in which the eye is led into and around the subject is more exciting and satisfying because the viewer is taking part in the picture.

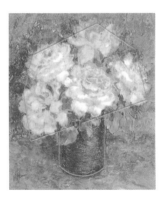

Breaking the symmetry
Floral subjects have a built-in tendency toward symmetry; it is natural to want to place the vase in the middle of the picture so that you can fit all the flowers in. You can do this safely as long as you arrange the flowers themselves in such a way that the symmetry is broken.

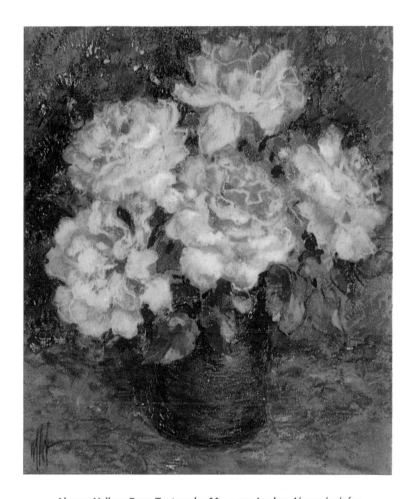

Above: Yellow Rose Texture by Maureen Jordan *Always look for the main shapes. Here the bottoms of the blooms make an upward-sloping diagonal, and the flower at the top is not placed centrally. The group of flowers makes a geometric shape that counterpoints the cylinder of the vase.*

I don't understand what is meant by an interaction between subject and object. Can you show me an example?

Above: Sunset by Barbara Benedetti Newton. *The subject of the painting is the sunset. The object of the painting is to create an emotional response in the viewer through complimentary color, dramatic lighting, and unusual shapes; to provide the viewer with a dramatic and somewhat unusual view of a sunset. Instead of a horizon with a setting sun, it is peeking through foliage that creates a bright spot and colorful halo. The color of the halo is repeated as light floods the road between the trees.*

How can I create a sense of movement in my picture?

Curved or diagonal lines are often used as a compositional device, because the eye will naturally follow them. In a landscape, these lines could be provided by a path or river running from foreground to middle distance, or by the furrows of a ploughed field. In a still life, you could place drapery so that a series of folds travels from the front of the table-top to the group of objects.

Can you tell me how to create a vignette?

In pastel painting it is possible to concentrate solely on the main subject and omit the background altogether, by means of a technique known as vignetting. The idea is to leave an area of the toned paper around the subject and gently fade out the edges with soft strokes that appear to melt into the surrounding paper. In order to achieve an integrated, harmonious result, it is important to leave areas of untouched paper within the subject as well as around it. For instance, in a portrait the buff-colored paper can serve as the middle tone for the colors of the flesh. If the subject itself is too thoroughly filled in, it will simply look as though you have forgotten to paint the background.

Above: Portrait of a young girl by Robyn King *Here the soft strokes of blue picked up from the girl's dress appear to melt into the toned paper. Unity is achieved because the tone of the paper appears to reflect the flesh colors used in the girl's face.*

What do I need to know about balance and contrast when planning my painting?

Although you can unify the composition by repeating shapes and colors, there is a danger that the picture may become dull through over-repetition. The elements of shape, color, and value need to both balance and contrast to be interesting.

Below: Time For Roses by Rosalie Nadeau
The most obvious feature of this painting is its richness and unity of color. The brilliant turquoise of the water is echoed by other vivid blues on the dress and railing. But the composition is equally important and skilful, with verticals and horizontals balancing the diagonal shape made by the figure.

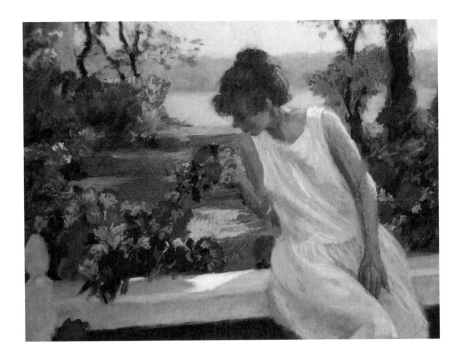

Composing with shapes

The figure marks a strong diagonal, thrusting from foreground to sky. This is balanced by the opposing diagonal of the railing, and intersects the horizontal shadows and waterline.

What are thumbnail drawings and why are they useful?

Small pencil or charcoal sketches are another way of planning your composition and value range.

Below: *Sketches like these take longer than masking a photograph, but give you more opportunity to rearrange shapes and organize the tonal structure.*

A vertical format shows more sky. This provides light area to balance the path at the bottom.

A square shape sacrifices the vertical sweep of the left-hand trees but gives more emphasis to the large right-hand tree.

More sky is visible in a horizontal format; the foreground was cropped to accentuate the shadow of the right-hand tree. This sketch was chosen for the final painting.

What is the purpose of making sketches of the scene I want to paint?

It is advisable to carry a sketchbook as well as a camera, because drawing a scene allows you to express a personal response in a way that taking photographs does not. Making a sketch commits the subject to memory better than taking a photograph too; even if you only jot down a few penciled lines, you will be forced to look at the scene in an analytical manner and decide what is most important to you for your planned picture.

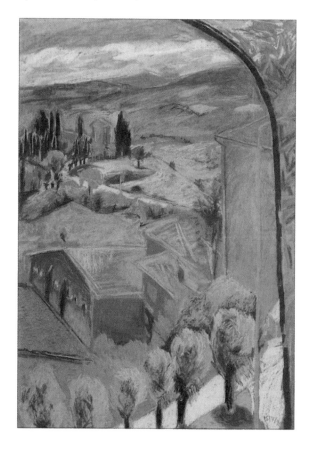

Right: Landscape By Casole d'Elsa by David Cuthbert *This artist has several sketchbooks filled with drawings, which he looks through for ideas. He combined three pencil drawings for this composition, omitting certain details from each. He sometimes backs up sketches with photographs for color reference, but he did not in this case because he wanted a free hand in his choice of colors.*

Working from pencil sketches

A quick, light sketch explores compositional possibilities. Notice that the curving lamp has been moved to the right in the sketch below right and in the finished painting opposite.

Buildings are treated in more detail here, in case this reference was needed. However, they have been simplified in the painting.

A bolder, more abstract arrangement of shapes. Foreground trees and tall building and trees on the hill are important features of the painting.

What are color notes?

Making accurate color notes involves recognizing colors and describing them meaningfully to yourself. It is no good just writing down "blue" or "green." This will mean nothing to you when you want to use the sketch, but "very dark blue-green" or "pale gray-blue with a hint of violet" will. Some artists use a familiar reference to aid their memory, for example, "creamy coffee" or "Chinese-vase blue." Constructing color notes is a highly personal activity.

Pencil is an excellent and highly versatile sketching tool, which can record linear outlines and areas of tone. But, of course, it is monochromatic, so you will either have to make a separate color sketch or add written markings to the pencil sketch, a common practice among artists. There is nothing more frustrating than pinning up a series of pencil sketches a week after they were made, only to find them useless because you have no idea what the colors were.

If you are using pastel as your sketching medium, you can place the emphasis on recording the colors, but you may then find you have insufficient information on shapes and forms.

Look at your sketch critically when you have completed it, and see whether you think you could paint from it. If not, then make another, perhaps in pencil or pastel pencil, concentrating on whatever is missing from the first sketch. It will take practice before you get it right, but once you start working from sketches you will quickly discover what you want from this preliminary information-gathering and find the best way to achieve it.

Colored pencil

Above: Casole d'Elsa by David Cuthbert
Colored pencil is a good medium for making color sketches. As you can see from this study, it is possible to achieve considerable depth of color. This could be used as the basis for a finished painting.

Oil pastel

Above: Rooftops, Vaucluse by Joan Elliott Bates *If you like to work up finished paintings from on-the-spot sketches, try using a small box of oil pastels. These are less messy to use than soft pastels, as they do not produce dust and they require no fixing.*

Color and value tones

Soft pencils (4B and 6B) used to block in main shapes and areas of tone.

Extra note needed here to remind artist of the varying edge qualities of the cloud.

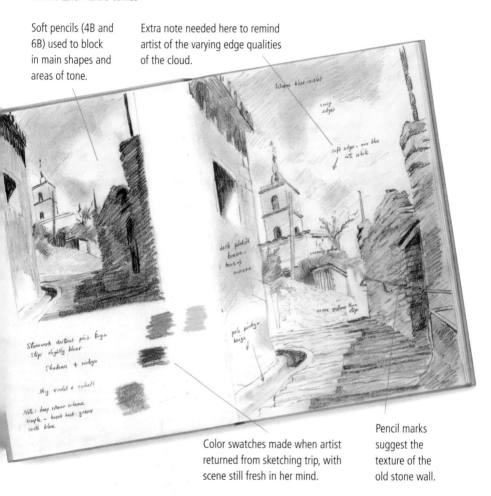

Color swatches made when artist returned from sketching trip, with scene still fresh in her mind.

Pencil marks suggest the texture of the old stone wall.

Above: St. Laurent-de-Cerdans by Hazel Harrison *Pencil sketches can provide adequate visual reference, provided that you make notes about colors, as the artist did here. She also backed up the full-page sketch with a smaller one exploring the distribution of tones. The dark wall on the right and the shadow on the steps are an exciting aspect of the subject.*

Is it all right to use reference photos?

Although inexperienced artists should work directly from a subject whenever possible, there are occasions when this is not practical. You might be planning a painting too large to complete in one session, or you might want to catch a fleeting effect of light in a landscape that has vanished before you have time to commit it to paper. In such cases you should consider working up the painting indoors from visual references collected on the scene.

Some artists do this as a matter of course, because it gives them more freedom to compose the picture the way they want it. These visual references can be photographs or sketches, but are most often a combination of the two. The camera is an invaluable aid, since it allows you to record a great deal of information very quickly.

Working from photographs

Boats are not easy to draw, so a photograph can contribute more than a sketch.

This provided a reference for the fishermen's nets, which have been generalized in the painting.

This provides helpful color reference for the sea and boat, but the figures are silhouetted, with no color or detail visible.

A useful reminder of the colors of the fishermen's clothing and the shape of the right-hand man's hat. But the composition as a whole is poor.

Above: Cape Fishermen by Hazel Soan *If you work from a single reference, you have no choice of compositions to consider. The artist took several photographs, and having decided to feature the figures in her painting, made several rapid monochrome and color studies. The sketches were more valuable than the photograph of the figures, because they conveyed a better sense of movement.*

What should I consider when composing a scene from a reference photo?

When you review the photos you have taken to use as reference for painting, ask yourself what you like about the scene. If cropping doesn't create a scene you love, try extracting a small portion of a larger view.

Right: *When working from a photograph, do not automatically adopt the same format. Explore possibilities by masking different areas with four strips of paper.*

Exploring the options

A vertical format could work well, allowing the artist to exploit the trees' upward sweep.

A horizontal format centers the path. It could be made squarer, thus losing some of the left and right sides.

Left and opposite: Shadowland by Barbara Benedetti Newton *There may be times when it is best to use only the "heart" of a reference photo.*

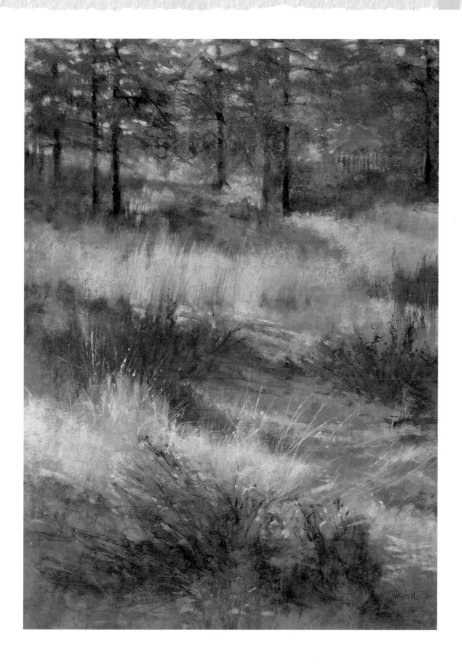

What are the challenges of using reference photos?

There are some points to keep in mind when using photographs only as your source of reference.

First, the colors are not always true. Film, printed digital images, or images on your computer display or handheld electronic device may not portray subtle nuances, so shadows often appear too dense, and skies an unnatural, uniform bright blue.

Second, a photograph ties you to a fixed viewpoint, whereas if you are in front of the subject you can move around to decide on the most favorable angle, and therefore the best composition. So do not restrict yourself to a single photograph; if you have several taken from different viewpoints, you can choose the most suitable or even combine elements from two or three.

There are small areas in my painting that I don't like. Can I remove the pastel to make changes?

People who have not used pastel are sometimes discouraged from trying the medium because they have been told that they cannot correct errors. It is true that you cannot erase a pastel line as cleanly as a penciled one, but there are ways of making corrections, particularly in the early stages.

If your first marks or your underdrawing go wrong, you can rub down the line to soften it and redraw on top, or flick it with a stiff brush, which will take off much of the pigment. To remove a line more thoroughly, use a putty eraser or bread, a traditional and effective cleaner. Do not try an ordinary rubber, because this may damage and scuff the paper as well as pushing the particles of pigment deeper into it.

If I have a painting that didn't turn out as I had hoped, can I start again on the same paper?

If corrections prove impossible on the particular paper, you can overpaint a part or the whole with white acrylic and allow it to dry for several hours. Pastel will go over this surface very well, and once dry, acrylic is impervious to both water and fixative.

This method can only be used, however, if you are working on a heavy grade of watercolor paper that will not buckle and wrinkle when under the wet paint. When you apply the paint, it will mix with the pastel, but this is an advantage, as it will provide a tinted surface on which to begin the new work.

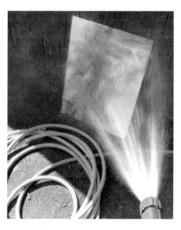

Left: *When drastic measures are called for, and if the surface you are using can tolerate water, you can go as far as hosing off the entire painting with a garden hose and sprayer. You will be left with a ghost image to begin again. Dry the paper by lying it face down on an absorbent surface.*

What do I do if the pastel in my painting gets too thick in an area?

If toward the end of a picture you find that there is an area you would like to change, and the pastel is too thick to work over, you can scrape away the top layers of pigment with the flat of a sharp blade and then use a putty eraser. This should be a last resort, because you can easily damage the paper unless you work extremely cautiously. You also run the risk of creating dust that spills onto adjacent areas; so either cover the rest of the surface with paper or pick up the dust with the eraser as soon as you have scraped it off.

Can you give me some tips about painting the details of buildings?

If your subject is a building of fine proportions or interesting shape, you may want to show all of it, but you can often make an equally attractive picture from an architectural detail, such as a door, balcony, or wall with carved stonework. This can be easier than handling the intricacies of perspective over a large scale, but you need to pay attention to composition and lighting. Do not place your chosen feature in the middle of the picture, and try to work on a sunny day so that there are shadows to provide good contrasts of tone.

Contrasting shapes

Right: East Livingston Place, Old Metairie by Sandra Burshell *The artist made a pleasing arrangement of tones, colors, and shapes—tall curves and firm diagonals and verticals. The low evening sunlight gives a rosy glow to the walls and casts shadows that strengthen the forms.*

Pointed shapes and diagonal lines lead the eye to this focal area, dark shadow above helps it to stand out.

Suggestion of curtain and of window bars prevents the window from looking empty and "blind."

Curving diagonal draws the eye into the picture and echoes the curve above central door.

Pattern and texture

Shadows create a visual link between door and foliage, and soften the shape of the door.

Above: The Yellow Door by Margaret Glass *The initial impact of this painting also derives from the organization of shapes and tones, with the dominant rectangle of the door balanced by the triangle of light stonework on the left and the curves of the cobbles below. But there is much additional interest in the patterns and textures of brick, wood and stone, contrasting with the freer forms of foliage and grasses.*

Solid pastel is used for smooth cobblestones; this contrasts with linear marks for grasses.

Long, downward strokes follow direction of the wood; patches of unpainted paper suggest texture.

CHAPTER

6

STILL LIFE

I really want to paint landscapes so why should I try a still-life painting?

Still life allows the artist to take control. You can paint any item around the home that appeals to you and arrange it as you please. And still life helps you to develop your skills, because you can take as long as you like to complete your work. There is no hurrying to catch your subject before the light changes or because your model needs a rest. Most artists turn their hands to still life at some point in their careers, and many specialize in this field of painting.

What are the two types of still life?

A still life can be any group of inanimate objects, from bottles or fruit on a table-top to a pair of shoes in the corner of a room; and it can be as simple or as complex as you like. But there are two distinct types of still life: the organized group, and the "found" subject. In the first, you choose items that you like to paint and arrange them to form an interesting composition.

Right: Brass And Dry Flowers by Barbara Willis
This group was set up with care: the objects were chosen to present an array of delicate colors and rich textures, which the artist exploited with smooth blends. The painting is unified by color but also by repeated shapes. The roundness of the small vase echoes that of the brass jug, the wings of the bird continue the curve of the fan, and the dried flowers make a curve in the opposite direction.

An organized group

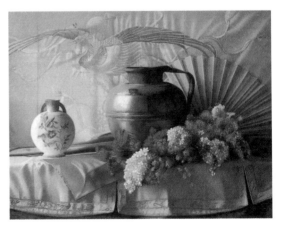

'Found" subjects

A "found" subject is something you happen to see, such as clothes in a wardrobe, a plant on a windowsill, or an open book left on a chair.

This classification also embraces paintings of interiors, which are still lifes with a visible setting. Throughout the history of art there have been many beautifully depicted interiors.

The 17th- and 18th-century Dutch painters, such as Pieter de Hooch, produced tranquil, highly detailed interiors. In the early 20th century, Pierre Bonnard and Gwen John portrayed the rooms in which they worked. Their paintings are more Impressionistic than those of the Dutch artists, showing perhaps a mantelpiece with objects, a corner of the room or a chair by a window.

When you find a subject, you are free to alter its composition; in an interior, for example, you could move furniture and ornaments. But the essence of the found group is spontaneity, so do not make it look too well-ordered.

Above right: Reflections by Sandra Burshell *This group was essentially happened upon and adjusted to improve the composition. There is, however, a carefully planned color theme based on the contrast between warm red-browns and turquoise-blue walls. The artist muted and "blued" the green of the plant so that it does not conflict with this.*

What should I consider when I choose a group of objects for a still life?

The label "still life" creates a mental picture of objects on a table top and the majority of still lifes do feature fruit, flowers, bottles, and so on, arranged on a surface roughly corresponding to the artist's eye level.

But any painting of inanimate objects can be described as still life. A still life usually has a theme giving the impression that the objects belong naturally together or ones that combine comfortably. Texture can also be a theme with

The natural look

Above: Morning Shadow by Sandra Burshell *This seemingly natural group was deliberately arranged, and the composition thoughtfully planned. It is based on a triangle, with the jug at the apex and the spoon, roll and newspaper forming the sides. The circular paperweight on the newspaper balances the circles of the fruit.*

components such as glass, metal, and fabrics selected for their surface qualities.

Or you could make color the main theme, choosing a collection of blue objects but including a yellow or red one for contrast. Contrast is always important in painting so to get an interesting result, avoid items that are all the same shape or color. If you decide to paint a bowl of fruit for example, see if you can introduce something angular as a counterpoint to the rounded shapes.

This linear touch could be provided by the back and front of the table top or a book or napkin.

Are there guidelines for arranging still-life objects within a group?

Artists who specialize in still life spend a considerable time setting up their groups, and you must be prepared to do the same. This is the first step toward composing the picture. There are no definite rules about arrangement, but bear in mind that even an organized group should look as natural as possible. Also, you need to establish spatial relationships that tie the different elements together visually.

Once you have made a preliminary choice of objects, assemble them, then move them around until the group coheres. If the composition looks cluttered, edit your original choice.

Novices tend to overcrowd their still lifes. Let certain objects overlap, and position some closer to the back of the table than others. Watch out for spaces between them; if one component is too far from another, it will become isolated and destroy the group relationship.

When you begin to feel that the arrangement is working, look at it through a viewfinder to check whether it will fit properly into your picture area; if not, make some final adjustments until you are happy with the appearance of the group.

ARTIST'S TIP

A centered still life should not be placed dead center with exactly the same distance on each side of the subject to the edge of the picture. A better composition would be a little off-center both horizontally and vertically.

You should avoid introducing too many colors to a still life, because they will tend to cancel one another out and the painting will lack coherence. Have some contrasts, though, of color and shape; in all these arrangements the oranges and yellows offset the deep blues, and the tall bottles make a good background for the predominant circles and curves. When setting out a still life, it is a good idea to start with more objects than you think you will need and gradually eliminate items as you try out different arrangements of them.

Exploring arrangements

Left: *Over-cluttered, and glass bottle color insufficiently strong. Jug facing outward draws the eye out of the picture. The pattern on the sugar bowl fights with the tablecloth.*

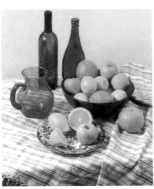

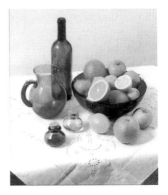

Above: *Much better. The jug now takes the eye in. Fruit in the foreground balances the fruit in the bowl, and the folds of the tablecloth give movement.*

Above: *White cloth shows up colors and creates attractive blue shadows from the glass. Could be toned down in painting to avoid stark contrast.*

I know lighting is an important element in any painting. What should I consider when lighting a still-life set-up?

Light plays a vital role in all painting. One of the attractions of still-life painting is that, because you are in control of your subject, you can play around with various lighting effects rather than taking the light "as you find it." The pictures below illustrate some interesting lighting possibilities.

Lighting a still life

Left: *Backlighting can be very effective. It darkens the colors of the objects and reduces detail while casting strong shadows directly in front of them.*

Above: *Here a low light from the side has been used, casting intriguingly shaped shadows and creating highlights.*

Above: *Light from directly in front is usually less successful, because the shadows are behind the objects and thus contribute less to the composition.*

Are there some compositional guidelines for a still-life painting?

You may think that you have finalized the composition once you have arranged the group, but this is only the beginning.

Before you start to paint, you must figure out what viewpoint to take, what shape the painting is going to be, and how you will place the subject on the paper. The viewfinder is helpful here. You may find that it reveals possibilities you had not previously considered, such as observing the group from above or below.

A high viewpoint, such as when you work standing up, is often effective for an arrangement that includes dishes or bowls, because it allows you to see more of the circles, introducing a pattern element. A low viewpoint from a seated position can work well for a group of tall objects, such as bottles.

If your still life is on a table-top, try looking at it from one side so that you see the corner of the table, rather than head-on, which gives you a hard horizontal line in the foreground. It is usually best to avoid horizontals, as they block the eye rather than leading it into the picture, creating a static effect. A device often adopted to break the line of the table edge is a piece of drapery hanging over the front and sweeping around the objects, making a series of curves and diagonal lines from foreground to background.

Left: Fruit Still Life by Catherine Nicodemo *A strong pattern derives partly from the way the fruit is arranged and partly from the high viewpoint. This enhances shapes because forms are less apparent, and it separates the objects from the flat plane on which they are resting. The artist emphasized the separation by omitting to paint any shadows beneath the fruit, so that they look as though they are flying upward.*

Choosing the viewpoint

You can spend time arranging a still life only to find that it loses its appeal when you return to your easel. This is because you have shifted your viewpoint, which radically changes the visual relationship of the objects. So before you begin to paint, look at the group through a viewfinder from your painting position, and if it still does not gel, move your easel, or work from a standing position so that you can look down on the subject.

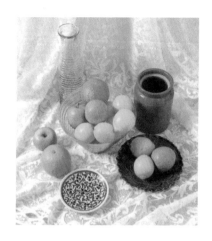

Above: High viewpoint *(standing position). Most suitable for flat objects, and works well for dishes and fruit. But the foreshortening of bottle and jar looks uncomfortable.*

Above: Eye-level view *is good, stressing diagonal side of bowl, tall glass bottle, and upward-sweeping folds of drapery. Also creates an oval ellipse of the plate in the foreground.*

Above: Viewing from the left *makes drapery take an interesting shape and causes the bowl to overlap the brown jar. Gives a pleasing impression of movement.*

How do I create rhythm and movement in a still life to keep it from being static?

The placement of objects, and light and shadow, will move the viewer's focus around within a painting.

Right: Soup Tureen, Fruit And Flowers by Maria Pinschof *Even though still-life objects are inanimate, they should not look static. Technique gives this picture a vigorous feeling. The loose scribbled marks enliven flat areas, such as the foreground table-top.*

I love shadows and reflections. Can I use them as an important element in my painting?

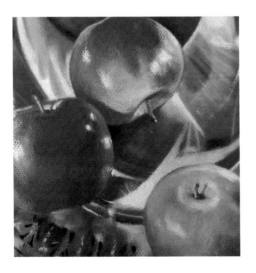

The shapes made by shadows can play as powerful a role in a painting as the objects themselves.

Left: Sincerely by Barbara Benedetti Newton *The stars of this painting are the apples but the supporting players are color, form, cast shadows, and reflections. They support the main subject and make it more interesting.*

How do I use color and value to define cast shadows and form shadows?

You can focus on the sculptural elements of volume and contour, modeling the forms with subtle gradations of light and shade, or you can emphasize the colors and textures, working the pastel marks into an almost abstract pattern that incorporates and takes advantage of all the variations of surface detail.

Depending on your approach, you may want to isolate the subject and treat it as a self-contained form, or you may prefer to give it a context that includes other objects and a recognizable background. When you are working with simple forms, the quality of light is important. Angled light will emphasize the structure of the object, whereas an even spread of light may flatten the forms and reduce the range of visual interest.

Below: Lemons by Sally Strand *The simple shapes in this composition are a strong vehicle for the artist's exceptional skill as a colorist. Each of the lemons is modeled with a range of subtle hues, from warm yellow and pink to cold blue, green, and lilac. The effect of brilliant sunlight derives from bold definition of the highlight areas.*

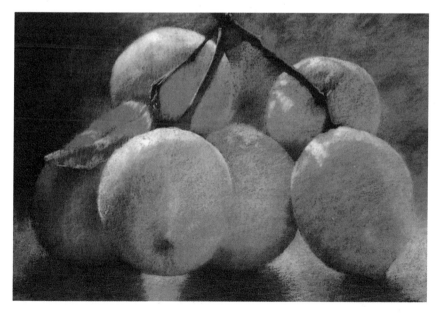

Can I paint flowers without every little detail?

Left: The Table By The Window by Doug Dawson *A flower does not need to have every petal and stamen drawn to read as a flower. The basic form and color will do the job and in fact will be more interesting. Squint to omit the unnecessary detail.*

How do I use flowers as pattern?

Right: Flowers And Duck by Jenny Webb *There is an inherent pattern in floral subjects, which is stressed here by treating the flowers almost as flat shapes and bringing in a selection of other strongly patterned objects. This painting is interesting in that it has no obvious focal point; instead the artist wove the shapes and colors into a tapestry-like effect across the picture surface.*

How can I make an interesting floral arrangement?

Arranging the flowers is the first step toward composing the picture, but adjustments will be needed when you begin to paint. You can enhance a tall or wide arrangement by cropping—that is, by letting one or two blooms go out of the picture at the top or sides. This avoids the uncomfortable impression of everything being squeezed in to fit the dimensions of the paper.

Above: Color Purple by Rosalie Nadeau *The flowers stretch beyond the picture at the top and right side. This makes them look more natural, because it suggests that they have a life outside the boundaries of the painting. The artist deliberately restricted her color scheme to harmonious purples and blues, with white providing tonal contrast.*

ARTIST'S TIP

In flower painting, a definite color theme will provide harmony in keeping with the subject. Depending on the color chosen, it can also create dramatic impact.

Why are flowers so frequently painted with other objects included in the picture?

Flowers are often combined with other objects in an arranged and orchestrated group. Such arrangements allow you to bring in color contrasts and experiment with different shapes, creating a more elaborate composition than you can with flowers alone. But be careful not to overdo the contrasts, and choose objects that have some relationship to the flowers so that the resulting picture does not look disjointed.

In the painting below lemons were chosen because they provide contrast for the deep, rich blues and purples of the flowers and vases. Note how the artist draws attention to them through lighting; they sit in a pool of light, enclosed by a curving shadow.

Right: Lemons In The Spotlight by Maureen Jordan *The dark tone of the background makes the flowers stand out, but colors pick up colors in the flowers and vase. Strong tonal contrast created by the white flower against a dark background draws the eye to focal point. A lemon overlapping the vase creates a spatial relationship and emphasizes a pleasing contrast of shapes.*

What should I do with the background in a floral painting?

In the majority of flower paintings, the background is left as an area of undefined space, with some slight variation of color suggesting the play of light and shade. But this does not mean that backgrounds are unimportant. They play a vital role in the picture, and you must consider which color or tone will complement the flowers. Avoid too much contrast between background and flowers, and bring in touches of flower or vase color to create a visual link.

Another option you might explore is setting up your group on a windowsill. This will give you a framework of vertical and horizontal lines, which can work well, as the straight lines contrast with the rounded shapes of flowers and the flowing curves of stems and leaves. You might suggest the view through the window with a touch of green or blue, but avoid detail or too much contrast, since this could detract from the main subject, or focal point.

How do I incorporate other objects into a floral still life?

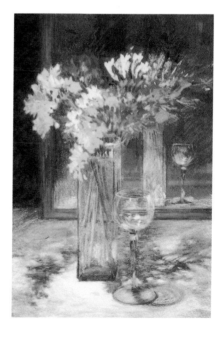

Right: Reflections I by Maureen Jordan
The artist solved the problem of a tall display by bringing in some still-life objects— the wine glass and mirror—to fill in the spaces, as well as making a feature of the foreground shadow. The mirror plays a double role, reflecting the glass and vase to create interest at the right of the picture and providing a background vertical that echoes the side of the vase.

What are some good pastel colors to have on hand for floral paintings?

You will need to add to your starter palette if you intend to specialize in flower painting, because many of the vivid oranges, brilliant pinks, and purples are impossible to achieve by mixing other colors.

Reds and pinks

Vermilion hue No. 6 Vermilion hue No. 2

Rose madder No. 6 Rose madder No. 2

Yellows and oranges

Lemon-yellow No. 2 Cadmium yellow No. 6

Yellow-green No. 3 Cadmium orange No. 6

Cadmium orange No. 4

Purples and violets

Pansy-violet No. 8 Pansy-violet No. 3

Purple No. 4 Purple No. 8

Mauve No. 3

What should I consider when deciding on a color scheme for my floral painting?

A pitfall when painting flowers outdoors is the presence of too much color. The rich medley that some gardeners love can appear disorganized in a picture.

Color themes

Look for a dominant color or a striking contrast, then play down the other colors so that they do not compete. A good contrast is that between complementary colors. A bed of orange marigolds, for example, would be enhanced by introducing touches of blue, perhaps by exaggerating a background feature, such as blue-tinged foliage. Yellow flowers can be set against patches of violet, or vice versa. The red-green complementary pair is a ready-made choice conveniently provided by nature, since red flowers have green leaves.

Below: Sunlit Patio by Jackie Simmonds *To balance the plant colors and create foreground interest, the artist has used a touch of yellow-blue as a contrast to the stone of the patio.*

FIGURES AND
PORTRAITS

Which type of portrait should a beginner start with?

A portrait focusing on the face is probably the simplest, because you do not have to cope with the complex forms of the full figure, or with hands—a notorious stumbling block. But because such compositions have only one element for the viewer to focus on, mistakes such as wrongly placed features will be glaring, so take care with the initial drawing.

To avoid the dull, staring, passport-photograph look, paint your sitter from a slight angle, and when you set up the pose, try to make the person feel and look comfortable. Do not hesitate to rearrange clothes and hair. In the portrait

here, the rhythmic curves of hair and scarf play an important part.

Below: Victoria by Ros Cuthbert *The painting shows how to achieve an effect by making small alterations. The line of the scarf was changed to make a strong vertical on the right of the picture, leading up to the face; in addition, it hides the hard line of the shoulder on the other side. The model is gazing into space, but in the painting she looks directly at the viewer, and this suggests a relationship that has formed between her and us, so that she becomes a living person whom we might know.*

Hair gives movement to an essentially static subject.

Scarf provides tonal contrast and continues the rhythm of the hair.

What are the steps of a head-and-shoulder portrait?

1 Working on the smoother or "soft" side of medium gray color Mi-Teintes, the artist begins with a careful drawing in charcoal.

2 The skin colors are pale and subtle. To set a key for judging these, the artist first puts in the bright background and some of the darker tones, such as this shadowed area of hair.

3 The medium gray of the paper also provides a contrast to the choice of skin colors. These are mainly pinks and white, lightly applied so that they are modified by the paper color. More pink is added to the lips with the edge of the pastel stick.

4 The face begins to take form, aided by work on the shadows in a blue-gray slightly darker than the paper. Light brown pastel is used to make delicate line strokes for the eyebrows.

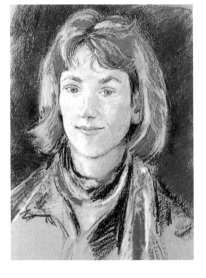

5 The painting has reached the stage where the artist can consider finishing touches and minor changes. Clothes are so far only suggested. The artist adds some bright turquoise to balance the vivid background, as can be seen in the finished picture, on page 188.

6 Because the pastel was used delicately, any major corrections are now inadvisable; but colors can be subtly altered. The ear was too pink, so charcoal is used to tone down the color. Again, you can see the effect in the finished picture.

Is there a list of colors that are used for pastel portraits?

You would not find it easy to describe pale or medium-tone skin with only the colors in the starter palette; so for portraits or figure studies you will need a greater range of light neutral colors with a pink or yellow bias, together with cool blues and grays for shadows. For darker skins and for hair, extra browns are recommended.

Try to identify the skin coloring. Skin is, of course, affected by lighting conditions, but you can nearly always recognize a basic color, which may be pinkish, ivory, coffee, or deep purplish brown—to name just some of the possibilities.

Once you have established this basic color you can begin to look for the colors of the shadows and highlights that define the shapes.

Pinks and browns

Madder brown No. 0 Cadmium red No. 1

Rose madder No. 0 Purple-brown No. 1

Browns, grays, and light blues

Vandyke brown No. 8 Sepia No. 5

Burnt umber No. 1 Cool gray No. 4

Green-gray No. 1 Cobalt blue No. 0

Yellows and yellow-browns

Yellow ochre No. 2 Yellow ochre No. 0

Naples yellow No. 0 Burnt sienna No. 2

Burnt sienna No. 0

How would I paint a group of people from a reference photo?

Our fellow human beings, singly or in groups, in action or repose, are probably the subject we encounter most often. But people are tricky to draw, and landscape can have a more immediate emotional appeal. However, if you set your figures in a town or a landscape, you will have the best of both worlds, and you will probably find that groups are easier to manage than a portrait or close-up figure study.

Accuracy of drawing matters less than general atmosphere, good composition, and well-balanced colors. If you work from photographs, try to interpret rather than copy. Here the photograph provided a reference for the figures and also for some of the colors.

Below: Harbour Fish Stall, France by Alan Oliver *Whereas the photograph is a jumble of colors and tones, the artist sets up a series of color links that unify the painting. Parts of the paper are left uncovered, so that its warm gray recurs throughout the picture, and pastel colors are repeated from one area to another. The pink on the underside of the umbrella can be seen again on the central figure and on the woman's coat.*

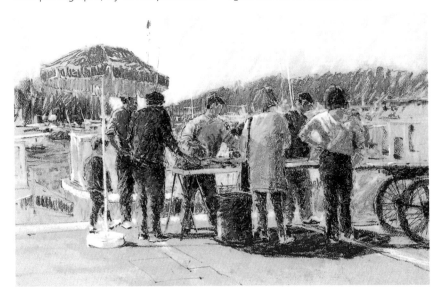

Fussy detail distracts the eye from figure group, so is omitted in painting.

The central figure is a pivot, linking the others, so it is emphasized in the painting with stronger color.

Foreground area was simplified to focus attention on the figures.

What are the steps in painting a group of people?

1 The artist made a pencil sketch in black and white from the reference photo. The artist often works from pencil drawings such as this, usually with color notes. In this case he has omitted the written notes, as the photograph provides adequate color reference.

2 An outline drawing is made with black conté crayon. This works well because it does not smudge. He then begins to lay on colors, starting with the darker ones, but keeping the marks light.

3 To help assess the colors for the seller, the artist began with the dominant shape, the umbrella, and now uses a similar pink. This links the two so that the figure stands out.

4 The sky is an integral part of the picture. Strong diagonal side strokes continue the sense of movement of the figures and suggest a windy day.

5 Because the strokes were kept open, colors can be overlaid without clogging the paper. The color of the hills is warmed by the addition of purple.

6 The artist works on the highlights, using a short length of pastel for maximum control. Fixative is then applied to allow further work, but the finished picture is not fixed because the artist finds that this dulls the colors.

7 Light pinkish brown was added to the foreground, leaving much of the gray paper showing. Detail here would detract from the figures, but some color was needed, along with a suggestion of perspective lines.

8 The central mast being drawn is important to the composition. It echoes the vertical of the umbrella pole and emphasizes the upward thrust of the figures. The masts also play a descriptive role, telling the viewer that this is a harbor scene. Conté crayon is then used for the final touches of definition.

What do I have to keep in mind when painting a figure in action?

Whether engaged in sports or performing everyday tasks, people in action make an exciting painting subject, but a challenging one. Especially if you work from photographs, remember to use the techniques that give an impression of movement: strong linear strokes or scribbled marks are better than soft blends. And back up photographic reference with information; become familiar with the way the body behaves when it is in motion by observing people and making quick sketches whenever you can.

Directional strokes

Heavily applied, decisive strokes communicate tension of an arm taking the weight of a pole.

Movement of water is conveyed by varied side strokes and lightly scribbled circles.

Firm linear diagonals and scribbles of black and white where the pole breaks surface of the water.

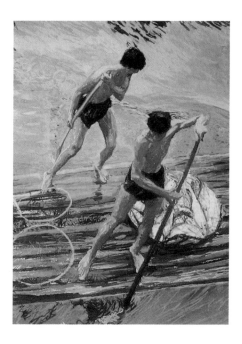

Above: Fishing, Banyan Lake by Kitty Wallis
The artist was prompted by the relationship between the movement of the bodies and that of the water, and expressed this rhythmic flow through her pastel marks. The strokes on the figures follow the direction of their movement, emphasizing the diagonal thrust, while inventively varied marks suggest the shifting of the water beneath them.

影助文学

How can body language be used to tell a story in a painting?

Even if you only intend to treat the human figure as an additional element in a landscape or urban scene, you should try to make each one look individual to say something about his or her character. You need not be concerned with features in such cases, but observe the general shapes and postures of people, and the attributes that mark their differences.

Watch how they move as they go about their routine activities, and look out for any typical gesture that will suggest what a person is doing.

Convey a feeling of movement by the way you use your pastels. Often just a few well-placed lines or some dots and dashes of color are enough to suggest the forms of the figures.

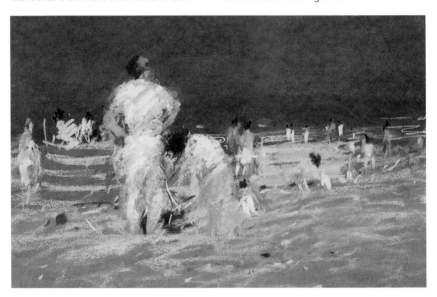

Above: A Norfolk Beach by Alan Oliver
None of these figures is treated in detail, and the more distant ones are just decisive flicks of pastel. They carry perfect conviction, however, because the artist has observed the shapes of their postures so well. The figure bending over the stroller, for example, is suggested with a few diagonal lines. Bold, lively pastel marks bring a strong sense of movement to the individual figures.

What considerations should I keep in mind when composing a painting of a group of people?

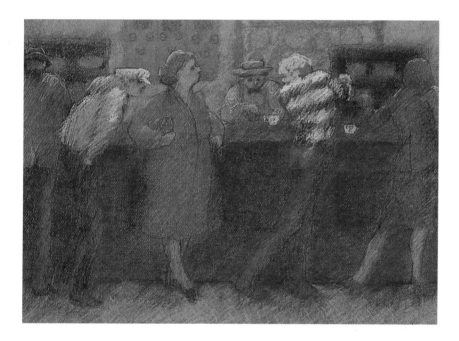

There should always be some relationship between the figures in a group. You can achieve this through technical devices, such as letting one figure overlap another. But you can also make the picture "tell a story," as the artist has done here, introducing a note of humor—and even a touch of caricature—by exaggerating the movements of the figures and their shapes.

Above: Double Decaf Low Fat Latte by Carole Katchen *Posture gives the impression of involvement. Both leaning figures enclose the woman in red, who is the picture's focal point. The tilt of her head and the positioning of her arms suggest an argument between the woman and the man in front of her. It is up to the viewer to interpret the scene. The height of the figure in the striped sweater and the length of his legs exaggerates the movement of his body.*

A frontal-view portrait sounds a little boring. What can I do to make it more interesting?

The best portraits contain the mood and style of the sitter. Hands can sometimes convey as much about people as faces do, which is why they are often included in portraits, but they should not be allowed to dominate the image.

Above: Jaymie by Rosalie Nadeau *This painting is cleverly organized so that the eyes focus first on the hands, but then travel upward to the face via the wrist and the red stripe on the arm.*

I want my figures clothed. How do I create the look of fabric?

Light and shadow play important roles in creating the look of fabric. The texture of the paper can also be used. Place very light areas next to dark areas to create a fold or crease. Solid areas of color with soft edges help to define the contours of the body.

Clothes can help to convey a feeling of the person, so it is not always a good idea to dress your sitters in their Sunday best, but rather have them wear their everyday attire. You can take this idea further and include objects in the painting that hint at the sitter's interests. This is a device often used by portrait painters—an artist is shown holding paintbrushes, or a writer with a pile of books on a table nearby.

Left: Heading Home by Sally Strand *This pastel and mixed media painting uses light and color to create the look of various textures and fabrics.*

CHAPTER

8

LANDSCAPE

What do I need to know before I attempt to paint a landscape?

Landscape is a popular painting subject, and it is easy to see why. We all enjoy walking or driving through the countryside, admiring the effects of changing light, the shapes of hills and mountains, and the colors of spring or fall foliage. It is natural to want to record some of these sensations. A successful landscape painting requires careful organization.

In a still life or indoor flower painting, much of the composition is arranged before you begin to paint. Obviously you cannot rearrange landscape features in the same way, so you must compose from what you have in front of you. Half-close your eyes and squint to distill your scene into large masses of form and value. Omit what is not needed to tell your story.

How does viewpoint affect a landscape?

Consider whether to take a high or a low viewpoint. This is important because it affects how much you can see of the landscape. If you are sitting on the ground in a field of long grass, you will have a fine view of individual stalks; but if you stand, you will see over the field toward the distance.

A low viewpoint, however, can be ideal for some subjects, such as mountain scenes where there is a relatively flat foreground and the main interest is the distant mountains. These will look taller and more dramatic the lower down you position yourself.

Creating Drama

Above: Cypress by Kitty Wallis *Here the viewpoint is low. The drama is created by setting the dark triangle of trees and hill against a pale but glowing sky that occupies a large part of the picture space.*

How do I make the most of skies and clouds?

The flat plane of the sea is often less interesting than the sky so it makes sense to place the horizon low, letting the sky dominate.

Left: Towards Ardnamurchan by Geoff Marsters *The artist built up the glowing colors with layer upon layer of pastel in downward strokes that suggest the weather conditions.*

Right: Breezy Day, Minsmere Beach by Margaret Glass *The artist uses a spatial approach but the strokes for the lively clouds are built color layer upon color layer in patches to create softness.*

How do I paint water?

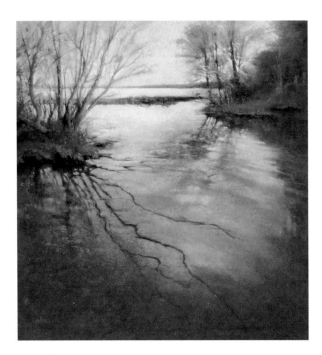

Left: **Winter by Barbara Benedetti Newton** *Water is defined by movement and the reflections that occur in reaction to the motion. The faster the water is moving, the more erratic the shapes will be.*

To begin, ask yourself if the water is moving. If it is, you will see only broken patches of reflected color. For a reflection to be complete and clear, the water needs to be still and transparent. As soon as the surface is ruffled or the water is opaque, the reflections will be fragmented and blurred.

Even after studying water for years, however, it can surprise you. For instance, a moving river which appears flat does not always reflect as clearly as you might expect. You will find on closer inspection that this is because the surface is a shimmering layer of water, which makes it opaque and distorted and does not reflect very well at all.

The fact that reflections are affected by the nature of the water means that you can use them to help describe the changing character of the surface, using repeated patches of reflected color for gentle ripples, clearer reflections for areas of flatter water, and fragments of reflected color in more agitated water.

How do I make interesting trees?

Trees can either be viewed as part of the general population of a landscape or as special features for close study. Trees have a fascinating amount of variation in their natural shapes, textures, and colors, depending on the characteristics of the individual species and the seasonal changes they undergo.

Although botanical identification is not an essential feature of tree studies, it is important to pay attention to specific visual qualities such as typical outline, branch structure, leaf shape, and color. The more you analyze the particular qualities, the more you can develop the richness and detail of a tree portrait or give definition and contrast to a study of grouped trees.

Below: Golden Gardens Pond by Barbara Benedetti Newton *Here the trees frame the composition and invite the viewer's eye deeper into the painting to the pond and beyond, into the distance.*

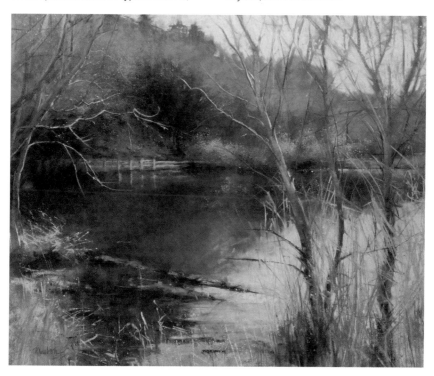

I want to include bushes and plants in my paintings, but I don't want to paint every little leaf. How do I paint foliage?

The immense amount of detail contained within any landscape view can be focused more closely in individual studies of foliage and flowers. This is an opportunity to experiment technically, and find out how the different kinds of pastel marks convey the extraordinary range of natural leaf and flower forms.

Because the shapes, textures, and color nuances in foliage are so complex, it is often tempting to settle for a broadly impressionistic style that creates a striking image but glosses over the characteristic detail of individual elements. Look closely at distinct properties of leaves or grass. Are they flat, wide, rounded, or reed-like? The subtleties of form and color will be details that make your scene look believable and accurate even to the most discerning eye.

Even when you limit yourself to an individual subject of this kind, there are still many different aspects to it. Your representation need not be realistic but look for the essential qualities that enable you to produce a convincing account of your own visual expression.

Left: Irises by Anthony Eyton
The mass of foliage is freely translated with gestural drawing, but the confident handling of the complex structure and varied color range produces a striking description.

Left: Cherry Tree
In Blossom by
Geoff Marsters *A
consistent pattern of
small, hooked linear
marks describes
variations of texture
and local color, relying
on the balance of
color to define form.*

What is backlighting?

Backlight is moody and atmospheric, creating a sense of mystery and stillness. Sometimes the light catches the edges of objects, producing a lovely halo of light; you can see this on the backs of the cows in the pastoral scene below.

**Right: Study Of Sunset
by Doug Dawson** *To
capture the effect of
backlighting, the artist has
worked mainly within a
narrow range of mid-to-
dark tones, kept colors
muted, and downplayed
details. He has brightened
the edges of forms where
appropriate to indicate
the way light glances off
their surface.*

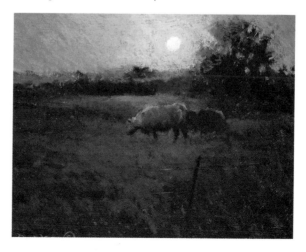

How do I paint light?

In some cases, natural light will be the very essence of your subject. For instance, the charm of a particular view will stem mainly from such effects as dappled light under trees or the warm colors of afternoon light giving extra intensity to the landscape hues.

Effective interpretation of light qualities comes in large measure from keen observation, but an equally important factor is confidence with your medium. Sometimes it helps to exaggerate contrasts of color and tone and be bold and free in your mark-making. When you step back from the drawing, the individual elements magically cohere into a striking image.

Below: Sutherland Coast by Aubrey Phillips *Pastel is a marvelous medium for capturing the fleeting effects of light outdoors because it is so quick and responsive. Here the artist has allowed the color of the paper to establish the overall tonality of the scene. Quick, calligraphic strokes and blendings give an impression of a gloomy day.*

What is an atmospheric landscape?

Pastel is the perfect medium for gentle, misty light effects. The only possible danger is that you may overblend to produce light tones and gentle gradations, or lose sight of color altogether and produce a picture in shades of pale gray.

Below: A Sense Of Place by Barbara Benedetti Newton *Although the artist blends colors in the early stages, the blends are overlaid with firm pastel strokes that give the painting an additional surface interest that, in turn, enhances the subject matter.*

ARTIST'S TIP
Your choice of warm and cool colors will give your paintings a feeling of depth.

How do I create the cool, diffused light of winter?

Although you sometimes see strong blue skies in winter, the light is usually more diffuse than in summer, and the shadows appear softer, with a blue bias caused by reflection from the sky.

Below: Winter Hedgerow by Jackie Simmonds *Here the delicate blue-grays and violets are enhanced by contrast with the warm red-browns of the branches and dead leaves.*

Contrasts of tone slight in distance; colors lightly applied and blended to soften lines.

A little yellow makes area stand out from more distant snow to create depth.

Pale yellow over blue-gray warms the snow color; snow seldom appears pure white.

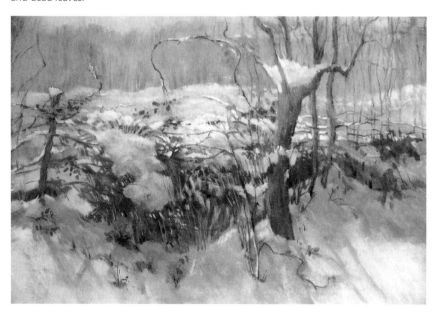

How do I create an impression of summer?

The prevailing light of any season dictates color and tones. When the sun is high in the bright blue summer sky, tonal contrasts are strongest. The cool blue casts of winter are replaced by strong warmer colors.

Below: Summer Sojourn by Barbara Benedetti Newton *Dappled patterns on the ground are created by the light coming through the foliage and tell the viewer that the sun is strong overhead. In full sunlight, colors may appear bleached to white.*

CHAPTER
9
FINISHING

I don't love my finished painting but I don't want to just throw it away; what do I do now?

Pin your painting to the wall where you'll be able to view it in passing. A good place is across the room from where you use a telephone. If, after viewing the painting you feel it needs "something," the first step is to try cropping the image to see if a different composition will make all the difference.

Above: *This picture might benefit from cropping the foreground.*

Assessing your work

Making a mat for your picture gives you a chance to reassess it, and you will sometimes find you can improve the composition simply by the way you place the mount. If you have worked right to the edges of the paper, you will have to sacrifice a little of the picture—the edges must be covered by the mat and attached to it—but you can crop much more drastically than this.

Above: *Cropping some sky focuses eye on the house and foreground.*

If you have placed the horizon too near the center, for example, you might lose some of the sky or foreground. Cut two "L" shapes as shown, and move them around on the picture to examine different options. You can use thick paper for this, or pieces of mat board.

If you decide on a cropped version, cut the mount to these new dimensions, but do not cut away any of the picture, because you may change your mind.

Above: *Central portion of picture makes an uncluttered composition.*

Cropping didn't help; what now?

Turn your painting upside down and pin it to the wall. After you have looked at it for some time, another scene may be suggested. Remove as much pastel as needed using a method appropriate for your paper and begin again.

ARTIST'S TIP
The reinvention of an older work can be a fun process. Use the "ghost" of the previous painting—the shapes and colors—as a guide for the new work and let your imagination do the rest.

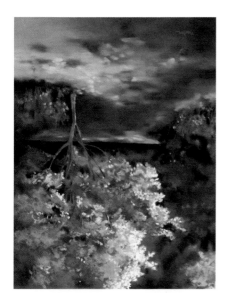

Above: *This is a fall tree painting that the artist was unhappy with, shown here hanging upside down.*

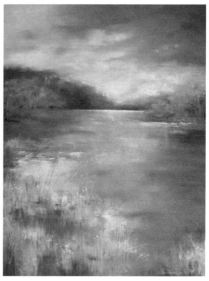

Above: Blessings by Barbara Benedetti Newton *Once a new scene was suggested, much of the pastel was brushed off to prepare the paper to accept pastel for a new painting.*

The painting is finished; what do I need to know about signing my work?

Your signature is another element of the painting and has an effect on the overall look. Discretion is best when it comes to signatures. A large signature with flourishes takes on a focus of its own.

Simply inscribe your name, in graphite, colored pencil, or a sharp pastel pencil, and position your signature in an area near the bottom that least affects the message of the painting.

My walls are full of my finished paintings. How can I store the rest and easily find the one I want?

Pastel paintings should be stored upright or face-up with something in between each painting to protect the frame and glass from damage.

Apply low-tack tape that won't leave an adhesive residue on the frame. Write the title and other identification on the tape and apply it to the side of the frame. When a painting is removed temporarily, remove the tape from the painting and place it nearby to remind yourself that the painting is not in inventory.

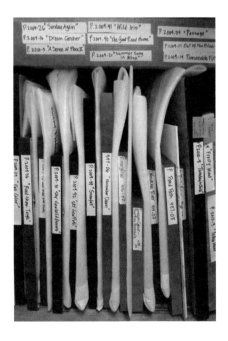

Right: *This artist uses handmade foam envelopes to transport art short distances. When not in use, these envelopes are used as protection and placed between each painting during storage.*

How do I store unframed pastel work?

There are several ways to store your finished but unframed pastels. If you have an abundance of wall space, you can tack them to the walls. This gets them out of the way but also gives you a chance to view them over time for any minor corrections.

Another method is to store them like clothes in a closet. Attach each painting to a coat hanger with a sheet of glassine or tracing paper on the front of the painting. You can store many paintings in a small area this way.

Unless you take steps to protect your work, it can easily become smeared, and the paper damaged. The best protection is provided by a frame and glass, but framing all your pictures could be very expensive.

Pastel paintings can be stored flat and you can stack them on top of one another, but they must be separated by tracing paper or glassine to prevent color transfer. The protective sheet should be fixed to the pastel paper, using artist's tape, so that the sheet does not move against the image when you are looking through your work.

ARTIST'S TIP

Keeping your pastels in a portfolio protects them from dampness and dust. The best type opens out flat, making it easier to look through your work periodically. Do not store the portfolio upright, as this could damage the edges of your work and cause pastel dust to drift downward.

How are pastel paintings best displayed?

How you show your pastels is a matter of preference. Up until recently, pastels were always displayed with a mat. Now, artists are beginning to frame their pastels without a mount. There is also a movement now to consider framing pastels directly against the glass, without the usual spacer or slip. If you mat your work, an off-white or neutral mat board is usually best so as not to detract from the painting.

Pastels must be framed under glass to guard against accidental smearing and to protect them from damp and dust.

Now that I'm done, how do I frame my pastel painting?

When framing work, the pastel must not touch the glass. If it does, moisture caused by condensation will make blotches on the picture surface.

Using a mat

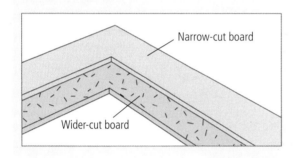

Narrow-cut board

Wider-cut board

Left: *You can make a thick mat by gluing two pieces of mat board together and cutting to size. For a more decorative effect, cut one piece smaller than the other, so that the edge of the bottom piece shows. In this case, use a contrasting color.*

Using slips

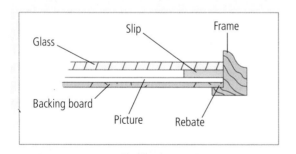

Glass

Slip

Frame

Backing board

Picture

Rebate

Left: *You can separate the glass from the picture by placing a thin piece of wood in the rebate (the L-shaped groove on the inside edge of the frame molding). You need a frame with a deep rebate.*

How do I safely transport a framed pastel painting?

If you are delivering a painting by car, the most important thing is to keep the image face up. That way, any pastel particles that are jarred loose in transport will not get on the mat but will end up in the channels left by the spacers or slips which is where they belong.

To ship your work long distances by air, your painting should be protected within a rigid cardboard box made specifically for art transport. Make sure the box is returned to you for re-use even if your painting sells at a distant show or gallery.

I've heard about "working in a series." What is that?

Work in a series refers to three or more paintings with a common theme. Working this way gives the artist an opportunity to explore a subject fully by use of different compositions and colors. Some artists choose the same subject to paint at different times of the day or in different seasons.

What is meant by the term "a body of work?"

When approaching a gallery requesting representation, or if you seek accreditation by an art organization, you may be asked to bring in a body of work.

A body of work consists of multiple pieces that are cohesive in nature, whether it is color, media, or subject matter that is the recurring element. The definition will vary by artist but the importance of having a body of work that will hang together compatibly is so that the viewer can hear your "voice" as an artist. There should be an ease in going from one painting to the next.

Glossary

Blending Fusing colors together, with the fingers, a rag, or a tortillon.

Blocking in Establishing the main forms and composition of a picture with areas of color and tone.

Broken color A term used to describe an uneven layer of color that is laid on deliberately so that it only partially covers the surface and allows colors beneath to show through.

Charcoal Used for sketching the layout of a composition and referred to as willow or vine charcoal, it is produced by burning twigs of wood in a kiln without air. Willow is the wood of choice because of its even consistency and fineness of particles. Vine charcoal is available in soft, medium, and hard consistencies.

Complementary colors Those colors that are opposite each other on the color wheel, such as red and green, yellow and violet, blue and orange. Each one increases the intensity of the other when they are juxtaposed.

Cropping The removal of the outer parts of an image to improve framing, accentuate subject matter, or change aspect ratio.

Crosshatching A technique of criss-crossing lines of color to create a fine mesh of color and tone.

Feathering The technique of making light, diagonal strokes over another color to lighten, darken, or otherwise modify it.

Fixing Spraying a substance onto a pastel so that the color does not smudge or drop off the paper. Fixatives are varnishes applied with a sprayer, mouth blower, or atomizer.

Glassine A very thin, smooth, translucent paper that is air- and water-resistant. Glassine is employed as an interleaving paper in bookbinding, especially to protect fine illustrations from contact with facing pages; the paper can be manufactured with a neutral pH, and can prevent damage from spilling, exposure, or rubbing.

Gutter A trough that catches excess pastel dust as it falls from a painting in progress that is mounted on an easel or wall in an upright position. It is placed beneath the painting and emptied occasionally. Make a gutter from aluminum foil, cardboard, or foam core.

Hue The term used for a pure color found on a scale ranging through the spectrum—red, orange, yellow, green, blue, indigo, and violet.

Impasto A technique of applying pastel or paint thickly so that none of the support shows through.

Optical mixing The juxtaposition of marks of colors so that the pigments do not actually mix, but at a certain distance appear to do so.

Plein air A French expression which means "in the open air" and is particularly used to describe the act of painting outdoors.

Primary Colors There are three colors that cannot be made from mixtures of other colors. These are red, yellow, and blue.

Scumbling Applying color loosely over another color to give an irregular, broken surface.

Secondary colors The three colors formed by mixing pairs of primary colors: orange (red and yellow), green (yellow and blue), and violet (red and blue).

Sfumato An Italian word meaning smoke-like. The effect is a soft, hazy quality in which the values of the colors merge into each other and build an image without reliance on linear structure or emphasis on edges and contours.

Stippling Applying color by using little dots of color rather than flat areas or strokes.

Support The term applied to the material that provides the surface on which a painting or drawing is executed, for example, canvas, board, or paper.

Temperature The term used to describe the relative warmth or coolness of a color. For instance, orange and red are warmer than blue and green.

Tertiary colors Any color formed by mixing a primary with a secondary color.

Tone (Value) In painting and drawing, tone/value is the measure of light and dark on a scale of gradations between black and white. Every color has an inherent tone; for example, yellow is light while Prussian blue is dark.

Tooth A degree of texture or coarseness in a surface which allows painting or drawing material to adhere to the support.

Tortillon (or torchon) A stump of rolled paper used to blend colors.

Index

Acknowledgements

Picture credits
2 Barbara Benedetti Newman, *October*
9 Kitty Wallis, *Morning Blue*
57 Barbara Benedetti Newman, *A Reason To Dance*
81 Pefkos/shutterstock.com, charcoal sticks
99 Barbara Benedetti Newman, *Edge Of Winter II*
129 Rosalie Nadeau, *Time For Roses*
169 Barbara Benedetti Newman, *Sincerely*
187 Kitty Wallis, *Fishing, Banyan Lake*
201 Barbara Benedetti Newman, *Golden Gardens Pond*
213 Barbara Benedetti Newman, *Serendipity*

Images in the public domain
pages 12, 52, 53, 90, 113, 120–121, 133